Cultural Leadership in America

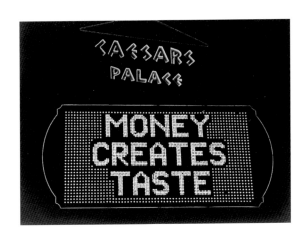

CULTURAL LEADERSHIP IN AMERICA
ART MATRONAGE AND PATRONAGE

ISABELLA STEWART GARDNER MUSEUM

Fenway Court

Volume XXVII

Published by the Trustees of the Isabella Stewart Gardner Museum
Two Palace Road
Boston, Massachusetts 02115
Copyright 1997

ISBN 0-9648475-5-8

The essays in this publication were originally presented at the Isabella Stewart Gard-
ner Museum as *Cultural Leadership in America*, the Museum's fourth annual inter-
disciplinary symposium, which was held in 1995 and was generously funded through
a donation from Charles O. Wood III and Miriam M. Wood.

Cover: Lucy Maud Buckingham Memorial Gothic Room, wall with window, c.1924.
Photograph © 1994. The Art Institute of Chicago. All Rights Reserved.
Half title page: Jenny Holzer, from *Truisms* and *The Survival Series*, 1986, Dectronic
Starburst double-sided electronic display signboard. Installation, Caesar's Palace,
Las Vegas. Courtesy, Barbara Gladstone Gallery.

Cultural Leadership in America: Art Matronage and Patronage
is volume XXVII of Fenway Court.

CONTENTS

Anne Hawley
Director

This volume of Fenway Court presents the papers given at the 1995 Isabella Stewart Gardner Interdisciplinary Symposium, the fourth in our ongoing annual series. The title of the session, "Cultural Leadership in America," is an auspicious one for us. As Isabella Gardner wrote in 1917 to her friend, Edmund Hill, "Years ago I decided that the greatest need in our Country was Art. We were largely developing the other sides . . . so I determined to make it my life work if I could." Her vision in the creation of Fenway Court (now the Isabella Stewart Gardner Museum) as a museum "for the education and enjoyment of the public forever," as her will states, set a precedent in America. Her bequest preceded those of J. P. Morgan, Henry Clay Frick, and Henry Huntington and also established a standard of munificent benefaction for future generations. Furthermore, she was devoted to the broader support of the arts through the intense energy and focus she brought to a broad range of daily activities and lifelong interests. Her

benefactions included the friendship, counsel, support, and patronage of American artists, writers, and musicians, including Henry James, James McNeill Whistler, John Singer Sargent, Dennis Miller Bunker, Charles Loeffler, and the young Pablo Casals, among many others. A supporter and contributor to cultural and public institutions, including the Boston Symphony Orchestra, the Museum of Fine Arts, and Boston Zoo, her public spirit extended to support of literary associations and hospitals, private donations to American museums, and even the offering of prizes for tenement house gardens. Her intellectual, civic, and artistic activities made Fenway Court an unprecedented American cultural center of activity. It is in the spirit of the cultural stature established by her that we celebrate this year's symposium and its interdisciplinary exploration of culture. It is also in that spirit that programs, including temporary exhibitions, artists in residence, the *Eye of the Beholder* lectures by individuals renowned for their visual and intellectual creativity

in various disciplines, a concert series ranging from music of the Baroque to contemporary jazz, and our exciting, ongoing work with students, teachers, and curricula in our local community, characterize today's Isabella Stewart Gardner Museum. Preserving and fostering the inspiration of great art, the Museum actively engages in scholarship, artistry, and the education of our youth.

The topic's coordinator, Dr. Wanda Corn, introduces the symposium and its other distinguished speakers in her paper, "Art Matronage in Post-Victorian America." That essay also examines the lives of three fascinating and distinctive women patrons of the arts: Isabella Stewart Gardner, Jane Stanford, and Alice Pike Barney. Dr. Corn is Professor of Art History in the Department of Art, Stanford University. From 1992 to 1995 she also served as Director of the Stanford Humanities Center and holder of the Anthony Meier Family Chair at Stanford University.

The symposium and this publication have been made possible through a generous donation from Charles O. Wood III and Miriam M. Wood. Their devotion to making accessible to our public the "life of the mind" has been the touchstone of their unstinting support for this Museum.

Wanda M. Corn
Stanford University

Today there is every reason to be deeply
concerned about the health and welfare
of our country's cultural institutions. The
troubles are many: the inability of muse-
ums to find directors who want the job;
institutions selling parts of their collec-
tions so that they can keep their doors
open; galleries in major city museums
open only on a rotating basis, or down to
three from six days a week. And now the
very real threat of Congress killing the
appropriations to NEA and NEH. So
when Hilliard Goldfarb asked me to or-
ganize the fourth annual Gardner schol-
arly symposium, and expressed the wish
that I dedicate it to some aspect of Amer-
ican art, it was Isabella Stewart Gardner
(1840–1924) whom I kept thinking about,
rather than the James McNeill Whistlers,
John Singer Sargents, and Dennis Bunkers
that she collected and hung in her first
floor galleries (fig. 1). It was Gardner as
self-appointed guardian of culture, as
museum founder, as cultural maverick,
and as dictatorial creator of the most
stringently worded will in American
museum history that inspired me to

Fig. 1. Baron Adolf De Meyer, *Isabella Stewart Gardner*, 1905. Courtesy of the Gardner Museum Archives, Isabella Stewart Gardner Museum, Boston.

dedicate this symposium to the history
of cultural leadership. My hopes are
twofold: first, to learn more about the
early history of today's troubled institu-
tions, many of which were founded by
members of Gardner's generation, and

secondly, to showcase what I take to be a newly revitalized scholarship around questions of collecting, patronage, philanthropy, and arts management. Since some of the best of this new scholarship looks for the first time at women as cultural leaders, the topic seemed a natural for a Gardner symposium.[1]

It was in the 1950s and early 1960s that a modern literature about American collectors first appeared. The first volumes tended to be biographies, written not by academics but by professional writers who gave us richly colored stories about outrageous and extravagant people. I remember vividly as a first year graduate student discovering this genre and taking from it anecdotes for many a future lecture. My reading included Aline Saarinen's *The Proud Possessors* (1958), S. N. Behrman's *Duveen* (1952), William Schack's *Art and Argyrol, The Life and Career of Dr. Albert C. Barnes* (1960), Louise Hall Tharp's *Mrs. Jack* (1965), and the related studies by Russell Lynes, *The Tastemakers* (1949), followed by the *Good Old Modern* (1973).[2]

With the appearance in 1966 of Neil Harris's *The Artist in American Society* and Lillian B. Miller's *Patrons and Patriotism* the emphasis on colorful individuals began to be supplanted by a more contextualized and scholarly view of leadership in the arts.[3] Each of these studies took on the 1790–1860 period and investigated the ways in which art-making was shaped by a host of players—some of them institutional—academies, governments, art unions, clubs, and societies—and others of them, individuals—minis-

ters, patrons, speculators, and museum trustees. Dealing with art both as a social and commercial practice, as well as an aesthetic one, these seminal studies, published thirty years ago, remain useful as references and guides to their subject.

In the 1970s and early 1980s, the two modes of inquiry—biographical and socio-historical—continued but without engendering much excitement in the academy or on the best-seller list. In recent years, however, the new interest in cultural studies has given new bite and provocation to our topic by producing a much more critical look at institutions, their founders, and their histories. Ranging from Larry Levine's *HighBrow/Lowbrow* (1988) to Neil Harris's *Cultural Excursions* (1990), and from James Clifford's *The Predicament of Culture* (1988) to Philip Fisher's *Making and Effacing Art* (1991), these studies have raised new questions about who has determined what goes into our art museums and what stays out; who runs museums and who does not; and the ties between museums, consumerism, spectacle, and business interests.[4]

Today it is the period *after* the Civil War that is under close scrutiny, beginning where Harris's and Miller's histories left off. It was the Gilded Age and later that saw the emergence of the country's millionaire collectors, the founding of the country's large cultural institutions, and the endowment of them not only with capital but with habits of thought and mission statements that still guide their actions today. This is also the moment, as Karen Blair has established,

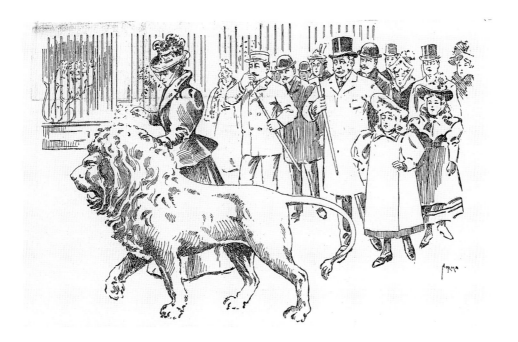

Fig. 2. "Mrs. Jack Gardner created a sensation at the zoo last week by leading one of the lions about the hall." Boston newspaper clipping, January 31, 1897. Courtesy of the Gardner Museum Archives, Isabella Stewart Gardner Museum, Boston.

when clubwomen collectively began to take their sanctioned identity as angels of culture out of the home and into the municipality.[5] There they founded amateur art associations, theater guilds, and music societies, establishing patterns of volunteer service still in evidence throughout our country in docent associations, art clubs, and women's boards supporting ballet, symphony, and opera.

If the 1880s and 1890s produced the first women's art clubs and associations, these years also yielded a critical mass of wealthy society women who emerged as individual art activists, founders of institutions, and collectors. They were this country's first important "art matrons," as I will call them, who established a distinctive style of "matronage." Isabella

Gardner of Boston may have been the most prominent of them, but she was not alone in leaving her city indebted to her for decades to come. There was also Bertha Honoré Palmer of Chicago, Louisine Elder Havemeyer of New York City, Jane Stanford of San Francisco, and Alice Pike Barney of Washington, D.C. And in their wake came Abby Aldrich Rockefeller, Electra Havemeyer Webb, Gertrude Vanderbilt Whitney, and many others whose stories and collections are well known in their localities but have yet to be tightly woven into our broader histories of cultural entrepreneurship in this country.

One important study that begins this synthesizing is Kathleen McCarthy's 1991 book on women art philanthropists

in this country between 1830 and 1930. McCarthy is the first historian to uncover a historical trajectory for art matronage in this country and very usefully compares matrons to patrons in her history. She dedicates a chapter to Isabella Stewart Gardner whom she sees as a key transitional figure between the Victorian and modern eras. For McCarthy, it is Gardner's heightened individualism and eccentric, non-conforming behavior that is her central attribute, a deviation from genteel societal norms that looks forward to the modern era when women became more independent in their public actions and outspoken in their convictions. She assigns Gardner to a kind of transitional or liminal space between the Victorian and modern worlds, constructing her as a pre-modern, a premonition of the "new women" to come and the "harbinger of a new philanthropic style."[6]

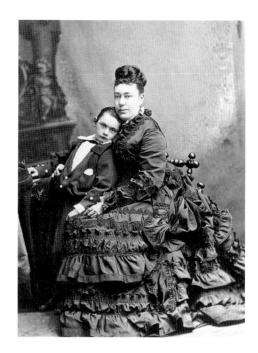

Fig. 3. Jane Stanford and Leland Stanford Junior, cabinet card, 1874. Courtesy of the Stanford University Archives.

I wish to differ in degree from that reading and make Gardner more typical of the women leaders of her generation—not just subsequent generations—than McCarthy generally allows. I'll do this by comparing Gardner to other wealthy society women who fashioned themselves as cultural philanthropists and public figures in the 1885–1915 period. Because their independent actions often stretched or broke with the codes of Victorian womanhood, these women, I want to suggest, too often get packaged as individual eccentrics or as domineering women whose personalities get more attention than does the fact that they spent years of their lives trying to shape the cultural life in their cities. Such an emphasis helps keep them incidental to American cultural history rather than centered in it.

What is now needed are studies that look at turn-of-the-century art matrons collectively and subject their non-conforming and dictatorial styles to anthropological analysis. In so doing, we would uncover a new female stratum of cultural leadership in this country whose constituents did not just anticipate a future generation of modern women but who, in their own right, were persons whose authoritative actions permanently changed the cultural landscapes of their hometowns. And while I cannot do justice here to the problematic of female eccentricity, let me suggest that we begin

to think of flamboyant behavior in this generation as a kind of period style, as a performative mode that women of this generation used to claim cultural authority in social settings where previously they had none. Outrageous public actions, I would suggest, were not a matter of isolated behavior but rather a more broadly adopted strategy among wealthy women who wanted to assert self-expression and independence of mind, but not at the expense of breaking with their social class—as would have been the case had they elected to settle in Greenwich Village. Eccentricity was a fin-de-siècle style that contained within it a critique of the status quo while at the same time carved out new kinds of public space and public reputations for women who had never had any before. (Sarah Bernhardt comes to mind as an international example of the success such behavior had during this period in giving a woman fame and authority.)[7] In a period when wealthy women were not asked to serve on museum boards of trustees, or to serve their cities in other public cultural roles, and when self-expression became an honorable and tolerated pursuit for those connected to the arts, Gardner and other women cultivated non-conformity as one way of accomplishing new public misions. Sometimes such non-conformity appeared as imperious and dictatorial actions; at other times, it was expressed through sensational modes of dress or attention-getting actions like Isabella Gardner walking a lion at the zoo (fig. 2). But whatever shape it took, women of independent mind emerged in American

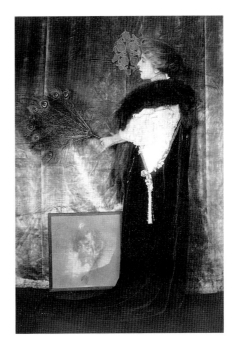

Fig. 4. Alice Pike Barney in Studio House, ca. 1915. Photograph courtesy of the Alice Pike Barney Archives, National Museum of American Art, Smithsonian Institution.

cities from east to west in 1885–1915, and are historically interconnected, sometimes in life-styles, but always in their decisions during their later lives to dedicate significant portions of their expendable time to improving public culture.

Let me profile some of the contours of what we might characterize as post-Victorian (rather than pre-modern) female leadership by giving you synoptic histories of two women who, though they lived many miles from one another, were sociologically related to Isabella Stewart Gardner. The traits they shared include the following: a sure and secure place in high society; the possession of a personal fortune, or marrying into wealth,

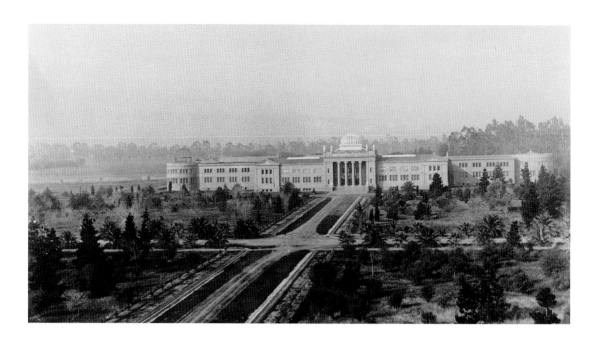

Fig. 5. The Leland Stanford Junior Museum, 1905, a year before the San Francisco earthquake. The central pavilion still stands and houses the Stanford University Museum of Art. Photograph courtesy of the Stanford University Archives.

or sometimes both; urban citizenship with a strong identification with their city and a pronounced sense of civic duty to bring culture to these centers; and most important of all, a desire that manifested itself sometime in middle to late life to be philanthropic, and to leave a cultural legacy that carried their family name. Two of my three examples cultivated an identity as a non-conforming woman as a way of opposing the conventionality of upper-class culture and of woman's restricted sphere, while at the same time, cultivating a frequent appearance on the society pages which the wealthy were accustomed to use as a gauge to their status within the community.

The first woman I want to introduce to you is Jane Stanford (1828–1905) who founded the Leland Stanford Junior Museum at Stanford University (fig. 3). Jane was twelve years older than Isabella, more conventional in her life-style, and more tied to classic Victorian female values. Stanford couched her philanthropy in the rhetoric of benevolence and charity, not that of willful non-conformity to genteel expectations. She was also wedded, as Queen Victoria was, to large-scale family memorials. She was unusual, however, and clearly post-Victorian in that she transferred the female prerogative of being dictatorial, managerial, and authoritative in the home into the realm of public institution-building. She acted imperiously in the public sphere. The second woman I want to consider is Alice Pike Barney (1857–1931) of Washington, D.C., who built Barney Studio House (fig. 4). Alice was twelve years younger than Isabella and cultivated an even more extreme reputation as a colorful personality. Giving credence to those feminists who have argued that women

do their best work in their middle to late years, all three of these women constructed their legacies in widowhood. In their spread of twenty-nine year's difference in age, the three of them exemplify the arrival of a new kind of cultural matron within the course of a single generation.

Jane Stanford was as determined and ambitious in her efforts to bring enlightenment and culture to her region as Gardner was in hers. Stanford's benefactions were directed to northern California, particularly to the peninsula south of San Francisco, on land where she and her husband summered and ran a horse-breeding farm. In the 1880s and 1890s, this area was a wilderness compared to Boston where people had been building and refining the urban infrastructure for well over two hundred years.[8]

Both Gardner and Stanford had only one child and both tragically lost them, events which drove each woman into a long period of depression. These losses surely helped make it possible for them to conceive large-scale projects. For each had time on hand that other women put into childrearing and family activities, and each had sizable financial resources with no immediate heirs. Gardner lost her son, Jackie, when he was a toddler and was told she could no longer have children; Stanford brought Leland Junior (1868–1884) into the world when she was forty years old and had no more children. By all accounts, not just those of Jane Stanford, her son was a precocious and learned boy who loved to travel abroad, study history, and collect antiq-uities. When he died suddenly from typhoid fever at the age of fifteen, both of the Stanfords were devastated. In their grieving, they determined to found a private university in their son's memory and name. They sited the Leland Stanford Junior University on their summer estate in Palo Alto, thirty-five miles south of San Francisco.

Leland Stanford Senior was a fairly typical Gilded Age tycoon, albeit one with a vision for institution building. He had been governor of California and by the time of his son's death, already made his millions as one of the four builders of the Central Pacific Railway. It was he who hired Frederick Law Olmsted and orchestrated the original plan for the university. But one project was Jane Stanford's from the start: the founding of the first museum in the United States west of the Mississippi. Conceived as a separate, or second, memorial to Leland Junior, the museum was initially intended for Golden Gate Park in San Francisco but ultimately built at the edge of the fledgling campus in Palo Alto. Its 1891 neo-classical building was based upon the National Archaeological Museum in Athens that young Leland had greatly admired.[9]

Whereas Isabella Gardner did much of her collecting before she built a museum, Jane Stanford erected a gigantic museum first and worked for the rest of her life to fill it (fig. 5). Encyclopedic in its vision, Stanford's museum—like other municipal museums at the time—was to be as much an archeological and ethnographic museum as an art museum.

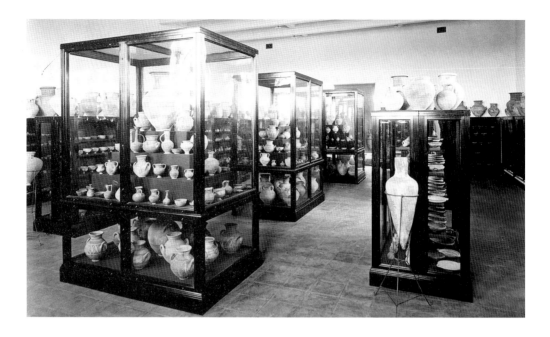

Fig. 6. The Cesnola collection installed at the Stanford Museum, 1893. Photograph courtesy of the Stanford University Archives.

Fig. 7. Eadweard Muybridge, Photograph of the art gallery in the Stanfords' San Francisco home, 1878. Thomas Hill's *Mount Shasta* and William Keith's *Upper Kern River* on the left-hand wall; a replica of Raphael's *Madonna of the Chair* in the far right corner. Courtesy of the Stanford University Archives.

Let me only hint here at the range and diversity of its holdings, many of which were bought in bulk as collections already formed. Given that their son had collected Egyptian bronzes, Greek vases, Tanagra figures, coins, and glass, and given the period interest in the beginnings of Western civilization, the Stanfords bought heavily in antiquities, acquiring, for example, five thousand pieces of the Cesnola collection of Cypriot antiquities from the Metropolitan Museum (fig. 6). Jane Stanford then went on to acquire collections of Coptic textiles, Egyptian bronzes, prehistoric stone tools from Denmark, American mound relics, Northwest Coast Indian material, and Japanese and Chinese antiquities. Both Stanfords also worked to increase the painting collections they

had in their residences, knowing that they would someday be transferred to the museum (fig. 7). Leland Stanford, probably advised by Albert Bierstadt,

Fig. 8. Astley D. M. Cooper, *Mrs. Stanford's Jewel Collection*, oil on canvas, 1898. Stanford University Museum of Art, Stanford Museum Collections, 16294.

among others, formed an impressively large collection of contemporary American painting and photography—including Thomas Hills, Bierstadts, William Keiths, and the famous horse trotting photographs by Eadweard Muybridge—and Jane Stanford went on buying trips to Europe to acquire old master paintings.

When her husband suddenly died in 1893, just after the University opened, Jane Stanford, at the age of fifty-five, came out from under his shadow and presided over the entire university as well as the museum. She wielded fantastic power, controlling the university's budget as well as its continuing construction. For twelve more years, until her own death in 1905, she initiated the building of new campus facilities—a library, a chemistry building, a memorial archway and a Memorial Church dedi-

cated to her husband. (The first university president, David Starr Jordon, who failed in his attempts to get money from her for new faculty positions during this building phase liked to complain about being in the "stone age.")[10] And in two different building campaigns, she added thousands of square feet to her museum, making it indisputably the largest private museum in the world. She continued to collect on trips to the east coast, to Europe, and to Egypt and Japan—her museum always evolving and in a state of expansion. Like Isabella Gardner, she directed all of its operations, hiring recent graduates of Stanford to help her and not retaining a permanent curator until 1900. Like Gardner, she found herself without enough money to do everything she wanted, and in a highly publicized gesture put her jewels up for sale in London, but not before she had photographs taken and a painting made of them (fig. 8).

It is not simply historical ignorance that explains why Jane Stanford and her museum are not as well known as Gardner's and hers. Nature is much to blame. The year after Jane died, the great earthquake of 1906 destroyed 60% of the Stanford Museum as well as much of its colletions (figs. 9–10). Her home in San Francisco, which housed the great American paintings and the old master works which were to go to the museum, burned to the ground. Since the museum was not separately endowed, its fortunes were tied to that of the university as a whole, a university that suffered so much damage in 1906 that its contin-

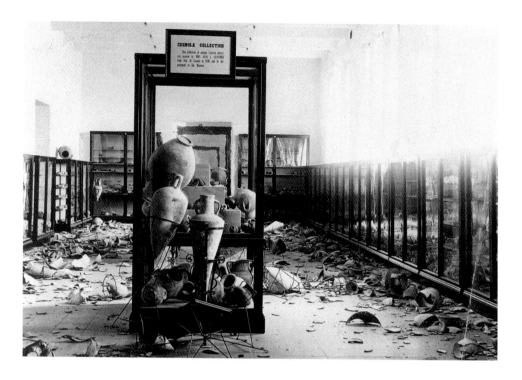

Fig. 9. Cypriot pots from the Cesnola collection in the Stanford University Museum after the 1906 earthquake. Photograph courtesy of the Stanford University Archives.

uation was in jeopardy. The museum was closed, its collections not yet catalogued. What survived was badly managed and thieved upon, and most of what remained of the museum building was given over to other academic purposes. Reopened in the early 1950s as an art museum, and slowly transformed into a modern collecting and exhibiting hall, Jane Stanford's museum once again had to be closed after the quake of 1989 and is now undergoing restoration and enlargement, soon to begin life over again.

It is Jane Stanford's unwavering vision for her museum, and her sure hand in seeing her vision fulfilled, that forms connective tissue between her and Isabella Stewart Gardner. Both women worked enormously hard to leave public legacies in the arts with their family names attached to them, though Jane,

older and more traditional, did everything in the name of her husband and son rather than in her own. Both consulted with experts but primarily made their own decisions. Both built, col-

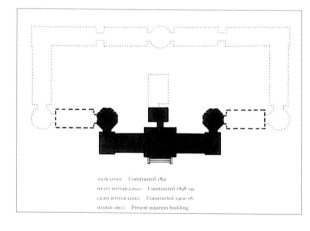

Fig. 10. The Leland Stanford Junior Museum, plan showing what remained after the 1906 earthquake. Drawing by Paul Venable Turner.

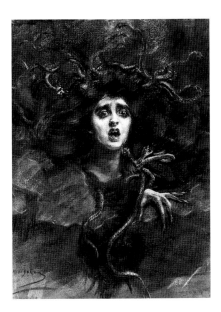

Fig. 11. Alice Pike Barney, *Medusa*, 1902, pastel on canvas. National Museum of American Art, Smithsonian Institution. Gift of Laura Dreyfus Barney and Natalie Clifford Barney in Memory of Their Mother, Alice Pike Barney.

lected, and directed their museums without boards of directors or professional staffs. Both envisioned themselves as philanthropists to their communities, educating and civilizing generations to come. And both were women whose sense of confidence and sure place in the world was strengthened not weakened by widowhood. Indeed only after they assumed sole authority over spending the family fortune did they accomplish their goals.

This was also true of Alice Pike Barney whose husband died just as she was completing her building project, a studio house that she would open for a range of artistic events. An artist rather than a collector, Alice never walked lions as did Gardner, but she did, like Gardner

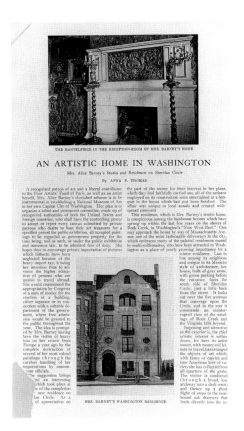

Fig. 12. *Town & Country* article about the opening of Barney Studio House, 1904. Courtesy of the Alice Pike Barney Archives, National Museum of American Art, Smithsonian Institution.

with her famous *décolletage*, dress to be noticed (fig. 4). She also hosted soirées, salons, musicales, pageants, and dance performances that were so progressive and self-consciously orchestrated that they were the talk of the social pages. Married to a man of completely conventional tastes who was embarrassed by his wife's public activities, Mrs. Barney remained in a loveless marriage. She resided in a typical Gilded Age mansion and summered in a shingle style "cottage" in Bar Harbor, Maine. Increasingly she and her husband went their separate ways, especially when Alice developed serious interests in being a painter,

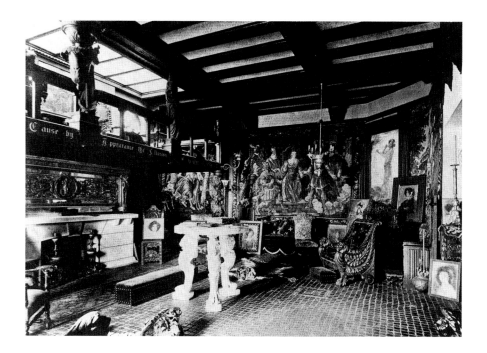

Fig. 13. West Studio, Barney Studio House, 1904. Photograph courtesy of the Alice Pike Barney Archives, National Museum of American Art, Smithsonian Institution.

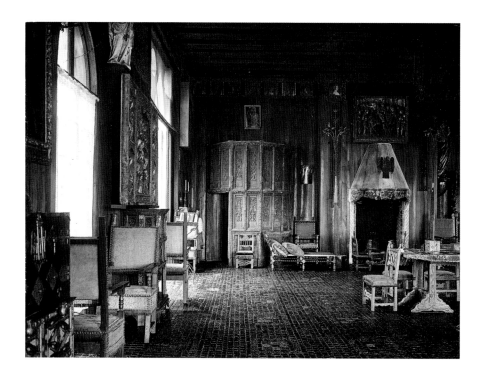

Fig. 14. The Gothic Room, Isabella Stewart Gardner Museum, 1926. Photograph courtesy of the Gardner Museum Archives, Isabella Stewart Gardner Museum, Boston.

seeking instruction with Whistler and others on her frequent trips to Europe (fig. 11). As she matured as a painter, and absorbed symbolist and fin-de-siècle tastes, she determined to overhaul the way she lived, dressed, and entertained. Like Gardner, she imagined creating a totally aestheticized environment, one in which the decorations, the furniture, and the arts on the wall together formed a spiritualized space. She bought a lot on Sheridan Circle, some distance away from the Rhode Island Avenue mansion she had come to hate, and with young Waddy Wood as her architect, designed her dream house.[11]

Barney house, opened a year after Fenway Court, was a studio house, not a house museum (fig. 12). Its scale was considerably smaller than the Gardner Museum and the paintings on the wall were not those of old masters but by Alice and her artist friends. Alice designed her largest room as a working studio, but it was also a space for theater and music (fig. 13). But despite the disparity of scale, there are many similarities between the two buildings, including the way the basic living quarters—bedrooms, bathrooms, and dressing rooms—were located on floors above the public rooms. Both women acted as artistic directors of their monuments. Stories are told about each of them directing and intervening in the process of designing, building, and decorating their homes, and it is clear that they both held a tight rein over the orchestration of their interiors, which like works of art, were designed to nourish the soul. Both endorsed a kind of historical eclec-

ticism typical in upper-class decor at the time, but they then tempered it by an arts and crafts emphasis on wood and fabric, tiled floors, tapestries on the walls, stone fireplaces, and heavy-set carved wooden furniture. These environments evoked old world châteaux but even more so, ecclesiastical architecture—Gardner's accented with Venetian gothic, Barney's with Spanish gothic (fig. 14).

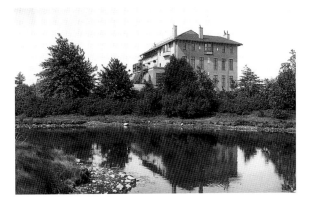

Fig. 15. The Isabella Stewart Gardner Museum from the Fenway, photographed by Thomas Marr, 1903. Courtesy of the Gardner Museum Archives, Isabella Stewart Gardner Museum.

For both women, it was the dark and moody mélange of textures, art forms, and period associations that made for the art spirit of the two buildings. And this was not to be experienced until you left the street, went through the portals and entered deep into their structures. The facades of the buildings, plain to the point of being uninviting (and therefore, rarely photographed), tell us nothing about the riches we will find within (fig. 15). They act rather as stone dividers, emphatically separating the material

world of money and competition outside the house from the artistic and spiritual world the two women created within. Inside both houses one entered a kind of *gesamtkunstwerk* where the architecture, the indirect lighting, the furnishings, and the art on the wall conspired to wrap the viewer in the effervescent spirit of art itself. The wholes were greater than the sum of their parts.

These women represented themselves as artists of domestic spaces, which is clear from their determination to leave their homes to their communities as ensembles, with everything in place. The stern and uncompromising language of Gardner's bequest is well known. Nothing in the rooms was to be changed or altered—and no works of art were to be added or subtracted. If they were, the museum was to be dissolved, the works of art sold in Paris, and the proceeds given to Harvard College. In Barney's case, she left it to her two daughters, Laura Barney and Natalie Barney, the latter a well-known lesbian poet, to carry out her wishes. She wanted her house to be used as a museum or art center for Washington, D.C. In 1960, the two sisters left Barney Studio House, with an endowment, and all its furnishings and paintings, to the Smithsonian with the understanding that it would be used to further the arts of the city. For many years it was used as office spaces. Then, in 1979, Joshua Taylor, director of the National Museum of American Art (called then The National Collection of Fine Arts) gave the building a modest restoration, put its furnishings back into place, and opened the house to the public as a museum to Barney and her literary and artistic circle. Theatrical and literary events were staged to resurrect the spirit of the place and the house came alive again for a decade.

Today however, the house is closed to everyone, its furnishings and paintings in storage, and its fate unknown. A metaphoric shroud hangs over the door. In 1995 the Smithsonian announced its intention to sell the building, an action that gave birth to the Friends of Barney Studio House, a group advocating its preservation and availability to the public.[12]

One reason to cherish both of these structures is that they are intact and reasonably untouched. They come to us as whole ensembles without having been disassembled by modernists who, had they the opportunity, would have most certainly put them through a purification process, whitening their walls, eliminating their furnishings, and increasing the wattage of their dim lighting. Both of these art-homes are fabulous period pieces that preserve that special moment —the Post-Victorian one—when the birth of the subjective self and the belief in aesthetic experience as the highest form of human activity combined to give us a wealth of new experiences that forced us to engage our inner selves. For theaters of the self, Gardner's and Barney's houses are right up there with symbolist paintings, Richard Strauss's operas, or J. H. Huysman's search for artificially induced pleasures.

But for me today, I present these structures—and here I include Jane Stanford's

museum—as exquisitely gendered and class-bound productions of the country's first generation of cultural matrons. Like Mary Cassatt's paintings, these buildings render visible the line that was crossed by a few wealthy women in the late nineteenth century from being angels of culture within a domestic setting to being queens of culture in public. As Anne Higonnet's explorations have shown, there was a certain "naturalness" in Gardner's transforming her home into a house museum, as women had sanctioned rights in the home that they did not have elsewhere.[13] So too with Barney's creation of her home as a studio house. Yet I think we have more to learn about this generation before we can thoroughly understand what made it possible for Jane Stanford, Isabella Stewart Gardner, and Alice Pike Barney in the very same three decades, and across the country from one another, to have the will and ambition and exert the raw power that it took to found their institutions.

Where did they get their moxie? Certainly their wealth helped, as well as their social standing, as well as the new freedoms women were asserting throughout American culture by the 1880s and 1890s. But how to explain fully the emergence within one generation, in cities across the country, of such confident egos, dictatorial styles, and, most of all, clearly articulated desires to leave a cultural legacy? For generations, wealthy men had publicly demonstrated their drives to acquire, possess, and bequest but with the exception of isolated examples, women had not. And once the

model of American art matronage emerged at the turn of the century, it expanded across the country as women —taking their own counsel—dedicated their financial resources and elected to put their time into founding art museums, house museums, and public collections. From Louise Murdock in Wichita to Jessie Mario Koogler in San Antonio, or the better known examples of Abby Aldrich Rockefeller and Gertrude Vanderbilt Whitney in New York, wealthy women began a hundred years ago to assert a powerful and directorial role in the country's cultural landscape. Isabella Stewart Gardner, as the founding mother of this museum, along with her sister art matrons elsewhere, dedicated their adult years to rewriting the script of women's leadership and benefaction in the arts.

1. I want to thank Anne Hawley, Director; Hilliard Goldfarb, Chief Curator of Collections; Patrick McMahon, Registrar and Assistant to the Chief Curator; along with other staff members of the Isabella Stewart Gardner Museum for their gracious hospitality and continual support during the planning sessions and day of the symposium. Their annual interdisciplinary symposium is a model of its type.

2. Aline Saarinen, *The Proud Possessors* (New York: Random House, 1958); S. N. Behrman, *Duveen* (New York: Random House, 1952); William Schack, *Art and Argyrol, The Life and Career of Dr. Albert C. Barnes* (New York: T. Yoseloff, 1960); Louise Hall Tharp, *Mrs. Jack* (Boston: Little, Brown & Co., 1965); Russell Lynes, *The Tastemakers* (New York: Harper, 1949) and *Good Old Modern: An Intimate Portrait of the Museum of Modern Art* (New York: Atheneum, 1973).

3. Neil Harris, *The Artist in American Society: The Formative Years, 1790–1860* (New York: George Braziller, 1966); Lillian B. Miller, *Patrons and Patriotism: The Encouragement of the Fine Arts in the United States, 1790–1860* (Chicago: University of Chicago Press, 1966).

4. Larry Levine, *Highbrow/Lowbrow: The Emergence of Cultural Hierarchy in America* (Cambridge: Harvard University Press, 1988); Neil Harris, *Cultural Excursions: Marketing Appetites and Cultural Tastes in Modern America* (Chicago: University of Chicago Press, 1990); James Clifford, *The Predicament of Culture: Twentieth-Century Ethnography, Literature, and Art* (Cambridge: Harvard University Press, 1988); Philip Fisher, *Making and Effacing Art: Modern American Art in a Culture of Museums* (New York: Oxford University Press, 1991).

5. See Karen Blair, *The Clubwoman as Feminist: True Womanhood Redefined, 1868–1914* (New York: Holmes and Meier, 1980) and *The Torchbearers: Women and Their Amateur Art Associations in America, 1890–1930* (Bloomington: Indiana University Press, 1994).

6. Kathleen D. McCarthy, *Women's Culture: American Philanthropy and Art, 1830–1930* (Chicago: University of Chicago Press, 1991), pp. 148–176.

7. I thank my friend and colleague Mary Lou Roberts for drawing my attention to Sarah Bernhardt.

8. The best sources of information about Jane Stanford are: Carol M. Osborne, *Museum Builders in the West: The Stanfords as Collectors and Patrons of Art, 1870–1906* (Stanford: Stanford University Museum of Art, Stanford University, 1986); Roxanne Nilan, "The Tenacious and Courageous Jane L. Stanford," *Sandstone and Tile* (Newsletter of the Stanford Historical Society) 9, no. 2 (winter 1985), pp. 2–13; and Gunther W. Nagel, *Jane Stanford: Her Life and Letters* (Stanford: Stanford Alumni Association, 1975).

9. See Paul Venable Turner, "The Architectural Significance of the Stanford Museum," in Osborne, *Museum Builders in the West*, pp. 92–105.

10. Nagel, *Jane Stanford*, pp. 157–158.

11. The definitive biography is Jean L. Kling, *Alice Pike Barney: Her Life and Art* (Washington, D.C., and London: National Museum of American Art; Smithsonian Institution Press, 1994). See also Delight Hall, *Catalogue of The Alice Pike Barney Memorial Lending Collection* (Washington, D.C.: National Collection of Fine Arts, 1965) and Donald R. McClelland, *Where Shadows Live: Alice Pike Barney and Her Friends* (Washington, D.C.: National Collection of Fine Arts, 1978).

12. In May of 1995, the Secretary of the Smithsonian Institution put Barney Studio House on the market, with the proviso that he would consider transferring the property to the members of another non-profit organization if they would maintain the house and open it to the public.

13. Anne Higonnet, "Where There's a Will . . . ," *Art in America* 77, no. 5 (May 1989), pp. 65–75.

Women Artists and the Problems of Metropolitan Culture: New York and Chicago, 1890–1910

Christine Stansell
Princeton University

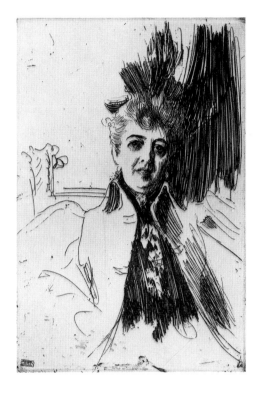

Fig. 1. Anders Zorn, *Mrs. Potter Palmer*, etching, 1896. Courtesy of the Isabella Stewart Gardner Museum, Boston. Bertha Palmer helped to lead the Board of Lady Managers in creating the Women's Building for the World's Columbian Exposition in 1893.

In a now-famous lecture in 1911, the Harvard philosopher George Santayana rued the power of women over American arts and letters. In comparison to Europe, Santayana avowed, American culture was a feminized backwater presided over by genteel ladies. Santayana's critique, although phrased as novel and revelatory, drew upon forty years of complaints about the supposedly overweening role of female consumers and tastemakers in imprinting American culture with moral uplift and improving sentiment—in short, in forging the Victorian link between art and bourgeois propriety.[1] The upper-and middle-class female audiences who were the subjects of the feminization discussion had long attracted detractors. They sponsored art exhibits and raised money for orchestras, devoured the light fiction of novels and magazines, and recoiled at the supposed excesses of naturalist and realist art. As embodied in Mrs. Doubleday, who urged her publisher husband in 1903 to suppress the vulgar and scandalous *Sister Carrie*, they represent to us now a rearguard Victorian stand against an onrushing modernist tide. But the problems of "feminization" also encompassed growing numbers of women in the late nineteenth and early twentieth centuries who themselves aspired to be

artists and writers, a social presence less easily saddled with the attributes of a class-bound gentility. Indeed, in the social commentary of the day, the aspiring women artists appeared as disorderly women of a troubled age, representatives of an incipient modernity rather than defenders of a moribund Victorianism.

Between 1890 and 1910, the situation of women in the arts became complex and, to us now, confusing. Women crossed virtually all the nineteenth-century sex bars in the arts, seeking admission to and employment in cultural sectors previously monopolized by men. But integration, as in the other professions, resulted in a resegmentation of hierarchies rather than equality of opportunity. The pressures women brought to bear were accommodated by redrawing the lines of sexual difference—the divisions between the properly feminine and the properly masculine—to create an expanded, albeit still segregated and often amateurish sphere for the "woman artist" alongside that of the properly professional "artist," normatively male. The division worked to confine women to traditional and conservative sectors and to disqualify them from the avant-garde.

But at the same time, the figure of this woman artist, rendered in the popular literature of the day, magnetized popular interest as one of a range of New Woman types who challenged the imaginative divide of sex. Neo-romantic and reverberating with a conviction in a transcendent enterprise of art, passionate in an unfeminine urgency to express herself, intent on earning her own living, the

woman artist took up a place as a character in a fin-de-siècle literature suspicious of female independence and unsupervised sexuality. She was an innovative and disturbing presence of frequently ambiguous class affiliations. Despite women's reputation as feminizers content in the Victorian backwaters of art, female artistry might betoken something new and modern for women, an engagement with polyglot city crowds, sexual freedom, and professional independence, not effete amateurism and domesticity.

The Feminization of Culture and the Woman Artist

By the 1890s, pressures from educated women on other areas of public life had transformed formal study in or sustained commitment to the arts from the nearly inconceivable option it had been for women in the early nineteenth century to a properly feminine pursuit. In the upper and middle classes, writing, painting, sculpting, and even some of the performing arts—singing and piano-playing—were deemed less draining in terms of family obligations and more easily reconciled with marriage than fully blown professions to which women were also seeking access, like medicine and law.[2]

Convention certainly accorded women a modicum of artistic authority, at least as tastemakers. Femininity imprinted itself on the high culture of urban elites, once wholly a province of gentlemen. Among wealthy women, artistic interests led to roles as patrons

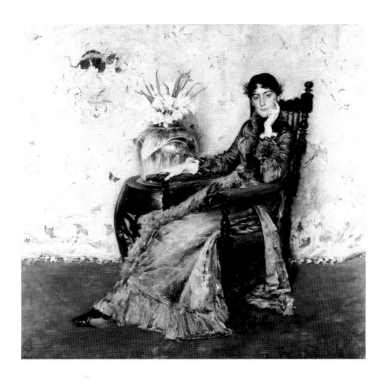

Fig. 2. William Merritt Chase, *Portrait of Miss Dora Wheeler*, 1883. © The Cleveland Museum of Art. Gift of Mrs. Boudinot Keith, in memory of Mr. and Mrs. J. H. Wade, 21.1239. Daughter of Candace Wheeler, and one of Chase's students, she started a firm with her mother and several other women where they established careers in the decorative arts.

and collectors legitimated by very old aristocratic antecedents. A few prominent rich women at the turn of the century drew upon this European tradition to acquire prominence and some power as hostesses and prescient collectors: Isabella Stewart Gardner of Boston, Louisine Havemeyer of Philadelphia, Bertha Honoré Palmer of Chicago (fig. 1), and the *salonnière* and painter Helena Dekay Gilder. Others sought an outlet for impulses of appreciation and aesthetic curiosity in the institution of the European Grand Tour—those pilgrimages to the art galleries, the castles, and the opera which Henry James had mocked mercilessly in *Daisy Miller* (1878) and which Jane Addams, herself a weary veteran, encapsulated as the "feverish

search after culture." And in civic life, middle-class women gave critical support to local cultural activities—musical events, art bazaars and fairs, scholarships for the young—which stressed uplifting sentiment and Protestant virtue, "an official American version of reality"—which upheld the cultivated tastes of its sponsors and audiences against the ever-threatening vulgarity of the masses.[3]

These were the promoters of the supposed feminization of American culture, which critics understood as a problem of female taste and male disability. Women, as patrons and consumers, preferred trivial and puerile work and thus prevented male artists from creating the virile, energetic art the times demanded. But there was also an uneasiness with women's

growing claim to be artists themselves. By 1910, the movement that in the antebellum years had been confined to the "scribbling women" of popular literature—Nathaniel Hawthorne's phrase—was writ large across the arts. In fact, the available statistics support the view that women were indeed pressing on occupations associated with arts and letters. In 1870, the presence of women in any Federal census category associated with the arts was small, in some cases tiny: 412 female artists compared to 3,669 men, for example. In 1900, men still outnumbered women in all categories except that of "music/music teacher," but the female increases in all fields were phenomenal: 13,875 male artists, 11,027 female.[4] The claim to professional seriousness as an artist had become one hallmark of the New Woman: "There are . . . more would-be *prime donne* in Chicago than anywhere else on earth," sneered an opera singer, a successful one herself, in 1913. Candace Wheeler (fig. 2), longtime patron of women in the plastic arts, struck a different note, exulting in 1897 that "there are today thousands upon thousands of girl art students and women artists, where only a few years ago there was scarcely one."[5]

In the visual arts, the emergence of the woman artist was far from a straightforward saga of emancipation into a transcendent realm of creativity and expressiveness. The profession, once women integrated it, reconfigured itself. The old sex bar, which had divided professional artists (male) from amateur dabblers (female), once bridged, gave way to a new division of the serious artist from the "woman artist," who might still be a dabbler but could also be assimilated into the lower realm of the commercial arts. Caught in the new configuration of sexual difference, female avant-gardistes would soon flee from the designation, "woman artist," repudiating the lachrymose and sentimental connotations of feminine work, its associations with middlebrow female supporters or uninspired hackwork. Yet even the women they abhorred, the prim and proper products of fin-de-siècle art education, cannot be understood simply as recruits in a last stand of Victorian culture.

By the turn of the century, young women of means found art school a readily available alternative to a college education. In Paris, the last bastion of sex segregation fell in 1897 when the Académie des Beaux-Arts, the premier school on the Continent, admitted women to its entrance competition. In the United States, the academies had opened to women during the Civil War years (fig. 3): Mary Cassatt, for example, had studied in Philadelphia at the Pennsylvania Academy of Fine Arts in the 1860s when the school, deprived of male students by the war, had turned to women to maintain its enrollments. Since its founding in 1875, the New York Art Students League had stressed its comitment to "women who seriously desire to study art as a profession." In Paris, the private *ateliers*, which prepared students to compete for admission to the Ecole, catered in the 1890s to women and benefited from the lucrative fees they paid—

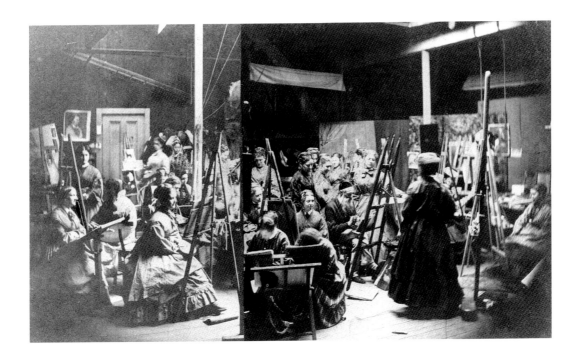

Fig. 3. Photographer unknown, *The Hunt Class*, ca. 1873. Private Collection. Photograph courtesy of Alice Kaprow. With few opportunities for professional instruction, women often crowded into classes like those taught by Willam Morris Hunt.

twice the tuition paid by men in some cases.[6] Yet despite being exploited for their fees, often ignored and insulted, badly taught and crowded into separate classes, women flocked to these schools. "The women students are almost as numerous as the men," a magazine piece on the Americans in Paris reported in 1896; "New York is swarming with girl art students," lamented the disapproving artist hero of *The Coast of Bohemia* (1899), William Dean Howells's thinly disguised portrait of the Art Students League.[7]

Throughout the nineteenth century, the critical issue that barred women from art classes was that of life drawing (fig. 4). For centuries, the core of an education had been careful, prolonged study of the nude model in academic life classes and private studios. But Victorian propriety militated against any decent woman seeing a naked body, male or female. Entrance to the life classes was thus a protracted and wearying battle for women, even after they were admitted to the schools. At the Julian in Paris there was a separate class with draped models for female students; this room had its own separate entrance and staircase to protect them from an inadvertent glimpse into the room with a nude model.

In the 1890s, however, life drawing began to fade as the critical marker of the gender divide. By the century's end, it was more often the case than not that women could work with nude models in the major schools. Rather, art school itself was coming to connote the realm of the respectably feminine. Art historian Lisa Tickner has argued that women's long-sought victory occurred at the moment when the academies, battered by

successive waves of secessions, surrendered any claim to forward-looking work. The women flooded the schools "just when the talented were getting out," she puts it drily, "turning bohemian, setting up brotherhoods and other kinds of antibodies."[8] By 1900, art school was to the European avant-garde hopelessly compromised by a desiccated academicism and serious students looked elsewhere than admission to the Ecole. In some respects, formal education had become a liability.

In America the situation was less clear cut because there was no avant-garde and the power of the academies was weaker to begin with. Still, it is fair to say there were similarities, as women moved in great numbers into the art schools at the moment when men were looking elsewhere, except for holding on to remunerative teaching positions. One secessionist "antibody" in New York was the group of realists collected around Robert Henri, men who mostly started out in newspaper sketch work rather than academic painting, a rebellious brotherhood which would emerge onto the public stage with a major independent exhibition in New York in 1908.[9] As "modern" art like that of the Eight signaled its permeability to expressivity, contemporaneity, and the signs and imagery of popular life in the metropolis, women entered classes where they studied neo-classical subjects and learned high finish brush work.

For the most part women graduated into corners of the art world untouched or only faintly tinged by modernism of

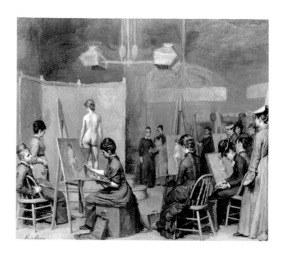

Fig. 4. Alice Barber Stephens, *The Women's Life Class*, ca. 1879, oil on canvas. The Pennsylvania Academy of Fine Arts, Philadelphia. Gift of the artist.

any sort: portraiture and decoration, genre paintings of rural life, still lifes of floral arrangements, misty landscapes, graveside statuary, prim busts and statues of local notables in provincial towns, miniatures, paintings of friends' houses. Henry James's description of Miss Blanchard's paintings in *Roderick Hudson* (1875) suffices for a tradition running strong twenty years later: "these represented generally a bunch of dew-sprinkled roses, with the dewdrops very high finished, or else a wayside shrine and a peasant woman with her back turned kneeling before it."

While in the mid-nineteenth century, then, there had been only "artists," with a handful of odd women trying to capture the title themselves, by 1900 a socially recognized "woman artist" had emerged, allied with middlebrow gentility. Her differences from "the artist" were en-

hanced by the support which women's clubs gave her, circumscribing her achievements within a circle of femininity even as they provided much-needed financial backing, sponsoring exhibits and bestowing medals on female painters and sculptors (this activity would reach its zenith in the grand exhibit of women artists at the Women's Pavilion of the Columbian Exposition in 1893).

The effects of the new differentiation are visible in a series on contemporary artists in 1896 in *Godey's Magazine*, the premier women's magazine of the day. To include women along with men in such a survey would have been unthinkable thirty years earlier—there were too few of them, and the occupation verged on scandal. By the 1890s, *Godey's* could turn its placid genteel gaze on both sexes in the *ateliers*. But at a historical moment when resentment of the mannish ambitions of the New Woman was raging, the magazine kept any such troublesome issues at bay by surrounding the subjects with the embellishments of sexual difference, so that any appearance that they were working at the same occupation as men was obviated.

The articles hinged on visits to each artist's studio, reflecting a new commercial practice in the cities whereby painters opened up their studios for public viewings, thus placing themselves within the precincts of urban tourism. "Artists" (male), while competing for the favor of genteel purchasers, nonetheless made a risqué bohemian demeanor a part of the package. They situated themselves in studios replete with signs and

symbols of exotic romantic creativity. In the magazine's tour the interviewer found his subject, the portraitist Eliot Gregory, settled in a room of soft Oriental carpeting and heavy draperies, low couches and divans, stained glass and Egyptian lattice work, down to a racy "hareem window." "Here amid beautiful bric-a-brac, the collection of many wanderings in France, Italy, Spain, and the East, Mr. Gregory practices his charming art."[10]

The "woman artist," however, was ill-fitted to display herself or her work in such surroundings. Women had less money for bric-a-brac and little *largesse* for the world wanderings that produced such decor (Cecilia Beaux, one of the most successful female artists of her day, traveled with a chaperone well into the twentieth century). In any case, the woman artist attracted too much suspicion in cultural commentary to allow practicing professionals to put themselves on view in the way men did. The women who opened their working quarters to *Godey's* presented irreproachably bright plain little studios. The sculptor Clio Huneker, one of the women interviewed, was known as one of Saint-Gaudens's most promising students and a woman-about-town in New York in the 1890s, a regular in a circle of musicians, artists, and writers who frequented the cafes of downtown Manhattan. Yet any traces of bohemian laxity were gone in the *Godey's* rendition. Huneker was featured as the mother of a baby, who comfortably merged her tidy studio with a well-run home.[11]

Commerce, the Cities, and Women Artists

But while the art schools channeled women into a feminized art, the regendering of the arts did not entirely quell the anxieties arising from this change. Their very existence still unsettled an entrenched system of gender segregation and male authority and clear demarcations of female respectability. Women artists thus attracted both the condescension of the innovators, who despised them for their supposed obeisance to academicism, and the disapproval of conservatives, who disliked their unwomanly ambitions and compromising independence.

At the heart of the problem of the woman artist was an uncertainty about her sexuality. Of all the arts in the nineteenth century, only acting had such transgressive connotations for women as did painting and sculpting. The stage had long been associated with prostitutes and *demi-mondaines* far outside the pale of female respectability. In the visual arts, women's entrance en masse was a relatively recent development, so the old identification with prostitutes was absent. But there was still an ambiguity that stemmed from the uneasy circumstances of women in the studios.

The troubling properties of the woman artist as a potentially disruptive sexual figure, whatever the actualities of her case, came from the age-old eroticization of women as the *subjects* of painting and sculpture. As art historian Linda Nochlin has argued, the gendered structure of the life classes in the nineteenth

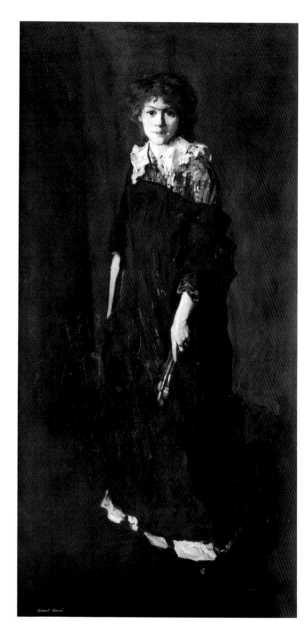

Fig. 5. Robert Henri, *The Art Student* (Miss Josephine Nivison), 1906. Milwaukee Art Museum, Purchase, Acquisition Fund. Josephine Nivison later married the painter Edward Hopper and surrendered her time to modeling for him and helping to manage his career rather than her own.

32

century—male artists, female models—made an esthetic of male gazing the basis of training. The centrality of naked women to modern painting meant that women seemed more properly objects than creators of art. Despite the ennobling frame of art, modeling could be a humiliation. At the Académie Julian, models disrobed before the class to await the collective verdict; catcalls and jeers forced a retreat. The opening of the art schools confused this situation, but not always to the benefit of female students. In some *ateliers*, women were sometimes asked to pose as part of their education. Women without support from home habitually modeled in order to pay their student fees; this was how working-class women students supported themselves.

By the 1890s, some uneasy accord, based on class differences about who was who, model or artist, developed: working women were generally the ones who "sat for the figure" while middle-class women with financial resources simply studied. Returning home from Paris, Robert Henri helped organize a sketch class at the Pennsylvania Academy which used, in a bohemian manner, the students themselves, male and female, as models. He found the women reluctant to pose, so much so that they sometimes feigned illness to avoid the session for which they were scheduled. Thus the visual arts were a place where women of different classes mingled, some to display themselves scandalously, others to paint. But the confusion of sexual references tended to tinge the woman painter with erotic projections and heightened

already strong associations between female independence, artistry, and sexual transgression.[12]

A string of novels of bohemia in the 1890s mulled over the conjuncture. The artist-heroines were popular variations of the American girl finely wrought by Henry James in the 1870s (fig. 5). Audacious innocents caught in impossible situations created by the vagaries of ill-conceived freedom and desire, they generally succumbed to some form of the seduced-and-abandoned plot, to be rescued in the end for marriage by some benevolent male artist. Cautionary tales to families considering sending their daughters off to Paris or New York, the narratives gloated over the defeat of female ambition but at the same time endowed the woman artist with considerable interest and energy.[13]

As artistic livelihoods for women became increasingly tied to commerce, wage-earning, with its connotations of unsupervised female sexuality, furthered the confusion. Increasingly, women artists who sought to support themselves, whatever their class origins, depended on the sphere of capitalist commerce rather than patronage or artisinal labor. A boom in publishing had ripple effects in the visual arts. Innovative technologies of reproduction fueled a brisk demand for illustrations for books, magazines, and newspapers; photography would not come to dominate commercial illustrating until after 1910. It was one thing for aspiring artists to paint dainty oils at home, another to tramp the streets and hang about newspaper offices looking for work.

Commercial illustrating broke down divisions between working and middle-class women, those trained in art school and those who were self-schooled. Female illustrators were something of an equivalent to Grub Street writers, working on assignment and piecing together a living from an assortment of employment. It was work which was not consonant with conventional dictates of middle-class women's propriety.

The early adult years of one of these artists, Mary Heaton Vorse, offers a glimpse into how the competing images of female artistry shaped one young woman's sense of herself at the fin de siècle. Vorse was a daughter of the upper middle class, born in Amherst, Massachusetts, in 1874, and raised to take up a place as a proper Victorian matron in New England society. "Art" was the teenager's way out. Literature did not attract her at the time — although within a decade she would become a talented writer; in the 1890s, the choice to write professionally would have stranded her at home. But she did show a bent towards drawing and so she convinced her parents to send her to Paris. It was a daring choice for a properly brought up girl.

Yet Vorse quickly slipped loose from the constraints of the genteel female artists, although her work itself never did. Her account of herself in these years was indebted to the fiction of the New Woman artist. In Paris, she seemed to herself a brave spirit; back at home after her time away, she felt herself slip into the great "female army of the defeated 'girls' whose parents had been stronger than they, who had settled down to wait for marriage, forever desiring that they might have their try in the world." Her determination to have that "try" finally took her to New York in 1896, where she continued to study at the Art Students League. In the city, her "brave spirit" swelled and she cut herself loose from her parents' support to launch herself as a commercial illustrator. For the first time in her life she was unchaperoned. In her own eyes she had thrown in her lot with another host of rebellious working women. Like other female wage-earners new to New York, she lived mostly alone and walked the streets looking for work. Economically, she supported herself with her art, psychologically, with a belief in herself as a heroine in a new story, that of "the army of women all over the country" who are "out to hurt their mother[s] . . . in order to work."

Conservative detractors of the woman artist would have cast her story within an imagery of friendlessness, misery, sexual vulnerability, and misbegotten ambition. Yet for Vorse, the negative associations of the woman artist with a compromised sexuality were emboldening. She felt herself in a metropolitan situation which we might see as incipiently modern rather than Victorian, replete with odd channels into social situations previously hidden from a woman of her class. Her life, penurious and dingy, was nonetheless animated by the "pleasures of the day," tinged with a diffuse sensuality and erotic imaginativeness which had once been the exclusive property of men-about-town. As she hunted for illustrat-

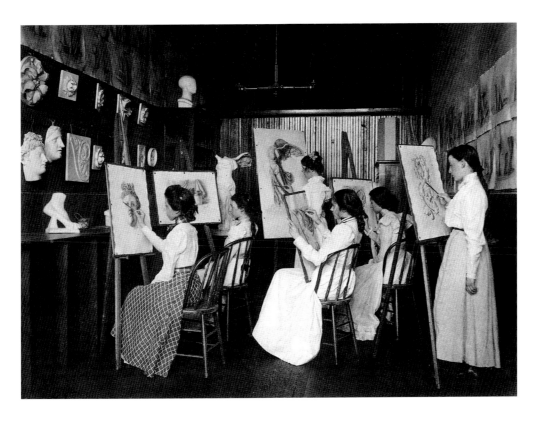

Fig. 6. Frances Benjamin Johnston, *Class of Female Students Drawing from the Antique*, 1899. Courtesy of the Library of Congress.

ing jobs, the life of the genteel woman artist mentally slipped into that of the ordinary working woman and even the "bad" women of the working poor. "The displacement of energy from dreams of artistic success to the practical reality of finding a job with a living wage," observes her biographer, "apparently increased her awareness of men, stoking her desire for 'impossible and forbidden' things."

It was not that Vorse was in fact in the same situation as a prostitute or a factory girl, or that she felt herself to be, but rather that her situation as a working artist dislodged the old feminine dichotomy of good woman/bad woman which

she had been taught. Her social position as a workaday artist bred a metropolitan imagination of "impossible and forbidden" things and the sexually compromised women who sought them. The odd and fleeting identifications with other working "girls" across class lines augmented her sense of a dawning erotic self. She toyed with thoughts of the "reckless irresponsibility that a woman of bad life must feel" and concluded, daringly, that it might be worth the price.[14]

In 1905, when she began to work as a journalist, Vorse would gently mock the admixture of romanticized indepen-

35

dence with mediocre talent which led young women to art school. The hard truth, as the now worldly-wise former artist saw it, was that desire to live in "as picturesque and romantic a manner as possible" landed recruits in seamy boarding houses and stultifying classes copying antique casts (fig. 6). What is interesting about Vorse's second thoughts, however, is how clearly she understood "the woman artist" as a focus of social imagination which served a quite different purpose than as a bulwark of conservative taste. For Vorse, the tangle of associations had provided threads that she had followed out to other parts of the city: from the "low" women artists who "sat for the figure" to "women of bad life" abroad in the streets.[15]

It is striking to consider her peering about covertly, since art historians have taught us to think of these fin-de-siècle cities as capitals of male voyeurism in which women looked down and away from an ubiquitous male gaze—including that of the artist—rather than around in their own right. We know from discussions of late nineteenth-century Paris that women looking *back* at the viewer and the artist, like Manet's *Olympia* and his barmaid, became emblematic subjects of modernism. With Vorse's story we can wonder about the extent to which the changing social location of the woman artist, which certainly incurred the disapproving glances of others, also allowed other women to look about in a new way as well.

1. "The Genteel Tradition of American Philosophy," in *The Genteel Tradition*, ed. Douglas L. Wilson (Cambridge: Harvard University Press, 1967).

2. See the major reassessment of American women artists in Kristin Swinth's "Painting Professionals: Women Artists and the Development of a Professional Ideal in American Art, 1870–1920" (Ph.D. diss., Yale University, 1995).

3. Kathleen D. McCarthy, *Women's Culture: American Philanthropy as Art, 1830–1930* (Chicago: University of Chicago Press, 1991); Alan Trachtenberg, *The Incorporation of America: Culture and Society in the Gilded Age* (New York: Hill & Wang, 1982). The Addams quote is from her autobiography, *Twenty Years at Hull House* (New York: Macmillan Co., 1910), p. 66.

4. Figures are taken from the printed Federal census tallies, 1870–1920.

5. Clara Louise Kellogg, *Memoirs of an American Prima Donna* (New York: G. P. Putnam's Sons, 1913), p. 320; Wheeler quoted in McCarthy, *Women's Culture*, p. 94.

6. The popular academies, Julian and Colarossi, offered female students, many of them American, a range of classes—many sex-segregated, some mixed—for generally twice the fees paid by male students. McCarthy, *Women's Culture*, chapter 4; Lucy H. Hooper, "The Art Schools of America," *Cosmopolitan* 14 (November 1892), pp. 59–62; W. S. Harwood, "The Schools of America," *Cosmopolitan* 18 (November 1894), pp. 27–34; L. Jerrold and Arthur Hornblow, "Studio Life in Paris," *Godey's Magazine* 132 (January–June 1896), pp. 128–135; Christine Jones Huber, *The Pennsylvania Academy and Its Women: 1850–1920*, exhibition catalogue (Philadelphia: Pennsylvania Academy of Fine Arts, 1973); Christine Havice, "In a Class by Herself: 19th Century Images of the Woman Artist as Student," *Women's Art Journal* 2 (spring/summer 1981), pp. 35–40; Jo Ann Wein, "The Parisian Training of American Women Artists," ibid., pp. 41–44.

7. Jerrold and Hornblow, "Studio Life in Paris," p. 132.

8. Tickner, quoted in Wein, "Parisian Training," p. 44.

9. Rebecca Zurier, "Picturing New York City: New York in the Press and the Art of the Ashcan School, 1890–1917 (Ph.D. diss., Yale University, 1988).

10. On visits to artists' studios see McCarthy, *Women's Culture*, pp. 95–97. William Merritt Chase, a successful society painter, was a master of the studio visit and the bohemian persona. See Mrs. Daniel Chester French, *Memories of a Sculptor's Wife* (Boston & New York: Houghton Mifflin Co., 1928), p. 61.

11. W. A. Cooper, "Artists in Their Studios X–Eliot Gregory," *Godey's Magazine* 132 (January–June 1896), pp. 187–192; "Mary E. Tillinghast, Anna Meigs Case, Mabel R. Welch," ibid., pp. 68–76; "Mrs. Huneker, Sculptress," ibid., pp. 356–361; Alice Severance, "Tales by Successful Women: Miss Bessie Potter, Sculptress," *Godey's Magazine* 133 (July–December 1896), pp. 356–360. For more on Clio Huneker, see Dee Garrison, *Mary Heaton Vorse: The Life of an American Insurgent* (Philadelphia: Temple University Press, 1989), chapter 2; Arnold T. Schwab, *James Gibbons Huneker* (Stanford: Stanford University Press, 1963).

12. Linda Nochlin, *Women, Art, and Power and Other Essays* (New York: Harper and Row, 1988), chapter 7. The scholarship on the relationship of female models to artistic training is fascinating. See Eunice Lipton, *Alias Olympia* (New York: Charles Scribner's Sons, 1992); April F. Masten, "Model Into Artist: The Changing Face of Art," *Women's Studies* 21 (1991), pp. 17–41. Saint-Gaudens, who had many female students, seems to have asked them to pose (in the nude?) as part of their training. *The Reminiscences of Augustus Saint-Gaudens*, ed. Homer Saint-Gaudens (New York: The Century Co., 1913), vol. 2, pp. 3–39. See also Hooper, "Art Schools of Paris," p. 62. On the Julian and on Henri's class, see Bernard B. Perlman, *Robert Henri: His Life and Art* (New York: Dover, 1991), pp. 9, 13. See also the striking photograph of a group of Henri's cronies in Paris posed with a nude female model in William Innes Homer and Violet Organ, *Robert Henri and His Circle* (Ithaca: Cornell University Press, 1969), p. 40. The entire practice now seems that much more intriguing with the evidence from Eakins's cache of photographs of nude students, mostly male, posed in a variety of clinical and (some argue) semi-pornographic ways.

13. The evolution of the discussion can be traced from novels which portray artists and the young women who want to marry them [Thomas Janvier, *Color Studies* (New York: Charles Scribner's Sons, 1885)] to artists who want to marry young women who aren't so interested. See Gertrude Fosdick, *Out of Bohemia: A Study of Paris Student Life* (New York: G. H. Richmond, 1894); George du Maurier's best-selling *Trilby* (Liepzig, Paris, London, and New York: Harper & Bros., 1894); William Dean Howells, *The Coast of Bohemia* (New York & London: Harper Bros., 1899); Robert Chambers, *Outsiders* (New York:F. A. Stokes Company, 1899); "Women–Wives or Mothers, By a Woman," in *The Yellow Book* 3 (October 1894) attempts to enfold the artistic-minded woman into a heightened role as the artist's companion.

14. Garrison, *Mary Heaton Vorse*, chapter 2. Vorse is known today for her involvement in the pre-war milieu of Greenwich Village intellectuals and radicals and for her career as one of the country's leading labor journalists.

15. Mary Heaton Vorse, "The Truth Concerning Art Schools," *The Delineator* (October–November 1905), pp. 706–710.

Women's Philanthropy for Women's Art, Past and Present

Karen J. Blair
Central Washington University

The feminist movement of the 1970s indisputably launched an era of change in women's political, economic, and social lives, providing opportunities and advancements in government, the workplace, and personal lives. During this era, women also saw new gains in the arts, notably a blossoming of arts institutions created for the work of women. Many of the founders of arts facilities were women donors who shared a respect for the creativity of women, felt that resources for women in the arts were meager, challenged the canon of worthies, and sought to give exposure and respect to women's works of art. While the impact of their efforts has been measurable, modern goals and gains resemble efforts of turn-of-the-century American women's rights activists. Despite the passage of over half a century, the parallels between women philanthropists of women's creativity now and then are striking.

Examples abound of contemporary women who founded facilities to enhance arts opportunities for women and educate the broader public to their value. Nancy Skinner Nordhoff, Seattle steamship heiress, spent $5 million in 1988 to establish a retreat for women writers on Whidbey Island, an hour from Seattle. The six "Cottages at Hedgebrook," nestled in a remote corner of Puget Sound, have continued to provide a luxurious haven for creative women. Since its opening, six women at a time, supported by a staff of ten, have devoted themselves fully to their writing, unencumbered by domestic or other responsibilities. Over the years, several hundred women have worked, for stays of ten days to six months, in a peaceful setting, to produce short stories, novels, poems, children's literature, plays, and essays on topics of every sort.

Another modern philanthropist is Wilhelmina Cole Holladay, founder in the 1980s of the National Museum for Women and the Arts in Washington, D.C. Wife of a self-made real-estate developer and publishing entrepreneur, she contributed a collection of paintings by women as well as millions of her own and her friends' money to refurbish a 1907 Masonic Temple. It stands only a

39

few city blocks from the Smithsonian museums and other venerable arts institutions in the nation's capital. There, its exhibitions of paintings by such artists as Angelica Kauffman, Anna Peale, Suzanne Valadon, and Alice Neel challenge the male-dominated canon of art on display down the street in such illustrious galleries as the National Gallery of Art.

Perhaps in modern times no creative work by women has fared better than the traditional women's needlecraft of quilting, a craft which has won the respect both of feminists who applaud the long history of women's work and traditionalists who continue to embrace women's household activities. No fewer than five quilt museums have opened in recent years, dedicated to the exhibition of antique and contemporary quilts. The oldest of these is the American Museum of Quilts and Textiles in San Jose, California, founded in 1977 by the members of the Santa Clara Valley Quilt Association. In Golden, Colorado, a suburb of Denver, Eugenia Mitchell founded the Rocky Mountain Quilt Museum in 1990 and donated one hundred quilts to its permanent collection. The following year, Meredith Schroeder, and her husband, Bill, donated ninety-one quilts to the collection of their brand-new American Quilt Society Museum in Paducah, Kentucky. In 1988, Mennonites Merle and Phyllis Good, with their in-laws, Rachel and Kenneth Pellman, established and managed People's Place, an Amish quilt museum, one of the components of their Amish Cultural Center in Intercourse, Pennsylvania, the heartland of Mennonite and Amish life. The New England Quilt Museum opened in 1988 in Lowell, Massachusetts. Collectively, these five new institutions have provided hundreds of exhibitions of both heirlooms and new work for the inspiration of new quilters and the enlightenment of the general public.

The donors of all these arts institutions have distinguished themselves as nurturers of women's creativity in unique ways, but their efforts also illustrate another noteworthy phenomenon in philanthropy. These founders are far removed from the traditional stereotype of rich industrialists who write fat checks for a pet arts project and proceed to fashion an institution from their personal vision. These donors instead reflect a vital movement to amass a supportive environment for women artists in self-consciously collaborative ways. They seek to involve wide numbers of individuals in their goal of institution building. Naturally, an expanded body of donors assists in solving their institution's endless demand for financing. Yet there has been considerable success in developing a broad base of women founders for women's arts institutions. One of my goals is to examine the ways that women's forms of collaborative philanthropy have had both positive and negative impacts on two of the new aforementioned institutions devoted to the visual arts, state committees for the National Museum of Women and the Arts and the New England Quilt Museum.

But if we imagine that these modern founders have been groundbreaking in

their efforts to forge wide partnerships for giving, we are unapprised of antecedents from the turn of this century. It should not be forgotten that early twentieth-century American women built on a vital women's movement and embarked on a similar mission to champion the creative work of women, seeking to sustain and promote it, and using ingenious alliances to achieve their collective goals. I also wish to review the Progressive Era efforts by women's amateur arts societies to found an environment to foster the creative work of women artists.

The National Museum of Women and the Arts (NMWA)

The National Museum for Women and the Arts, opened in 1988, has enjoyed considerable publicity as the first museum in the world to dedicate itself completely to the exhibition of women's art. The founder, Wilhelmina Cole Holladay, has deservedly received the lion's share of attention for her ingenuity and the millions of dollars she has contributed to the acquisition of a historic building in Washington, D.C., the collection of paintings by European and North American women painters she has assembled and donated to the museum, and her talent for securing considerable corporate support for a somewhat controversial enterprise. Critics have argued that the work she shows, by women who have not generally enjoyed recognition in traditional art museums, is not therefore worth defining as art. Others have com-

plained that her institution smacks offensively of feminism; some women artists have rejected this "ghettoization" of their work, refusing to permit it to be exhibited in a separate, all-women's arts institution. Nevertheless, Holladay has managed to attract funding from a healthy panel of corporate donors, including Philip Morris, AT&T, Martin Marietta, and Dupont, to create a formidable space for women's art.

Let us examine a heretofore unexplored dimension of the NMWA, the institution's eagerness to attract support, financial and otherwise, from a broad base of women. This brand of philanthropy has been initiated "at the top" by the leadership, not from the grass-roots as it has in quilt museums. But part of Holladay's genius lies in her ability to link her institution with modern women's consciousness of women's auxiliary status in past and present. Her strides in winning support of the museum on these grounds are considerable.[1] For example, the first thing you see when you walk in to the NMWA, long before you see a painting, is a large book at the Reception Desk. This book holds the names of all the charter members who contributed $25 when the facility was only an idea. Holladay invited multitudes of women to assist her in funding her museum, soliciting help from women she located on five mailing lists (museum catalogue buyers, upscale catalogue shoppers, female members of professional arts organizations, cultural program supporters, and members of women's rights organizations). With persistence, she

collected small checks from 85,000 women, enabling her to boast that her membership list trails only behind that of the revered and established Metropolitan Museum of Art and Art Institute of Chicago. The bound list of charter members of NMWA today is steadily fondled by guests to the museum who have come from distant places to view the results of their support. The prominent book reminds them that the effort to build this unique women's arts institution was shared.

The intensive appeal for charter members was only one of Holladay's inventions to build a foundation for her new institution. One of the most successful has been her invitation to each state to form a committee of women to generate a show of local contemporary women's art and fund its exhibition at the museum in Washington, D.C. The plan has had wide appeal, for it taps the pride of women volunteers, artists, and individual and corporate sponsors, even, and perhaps especially, in states far distant from the capital. To date, twenty-one states have responded with the formation of state committees and eleven of those have assembled shows for NMWA.[2]

Let us examine the work of the women in Washington State, who formed a State Committee in July 1987 and raised about eighty thousand dollars in two years to send a juried show of forty-three pieces (oils, watercolor, photography, glass, computer graphics, ceramics, and sculpture) by fifteen women.[3]

It was an artist, Nellike Langout-Nix, who blended the interests of women donors with women artists in Washington State. She organized the survey of women artists in the state and urged submissions of their work. Over 668 artists responded. The fund-raising chairperson, Ruth Gerberding, wife of the president of the respected University of Washington, arranged receptions for women who had been supporters of art in the Northwest and were not unwilling to associate themselves with a woman-focused museum. Among the five-hundred-dollar donors were Anne Gould Hauberg, founder of Pilchuck School for Glass and patron of Dale Chihuly, and Betty Hedreen, supporter of the Seattle Art Museum. Still, when only twenty donors offered five hundred dollars, there remained a need for additional funding to hold the competition, assemble the show, crate, insure, and fly the show to Washington, D.C., and back, print a catalogue, and fly the artists to a gala opening attended by their senators, congressmen, governor and their wives. To raise more support, lecturers toured state universities, senior centers, women's clubs, and other public fora with a slide show of women's art. Local communities came forth with small amounts of money when the exhibit was promised to tour in eleven Washington state communities.[4] The State Committee also won support from local businesses which did not generally support women or the arts. They were attracted by the opportunity to champion Northwest contributions in the nation's capital. Money came from such improbable sources as the Deep Sea Fisherman's Union, Olympia Brewery, Washington

State Apple Commission, Arbor Crest Winery, Puget Power and Light, Tree Top (apple juice) Cooperative, Boeing Aircraft, Kaiser Aluminum, and Weyerhaeuser. The enormous effort was successful. The museum in Washington, D.C., was publicized throughout Washington State, fifteen Washington women artists were featured in their home state and at the nation's capital, local sponsorship touted the Northwest on the east coast, and local women arts supporters used their talents for a cause they deemed worthy.

In bigger states with greater wealth, the fund-raising was not as exhausting to the State Committee members, but in each state new questions arose with the completion of the exhibit. How could local energy remain high for additional support for a distant museum? The Washington Committee, left with a budget insufficient even for postage to announce its meeting date to 1,600 members, has suffered stagnancy since the June 1989 exhibition. Its recent solution has been to nominate a new president, David Martin, gallery owner and writer on women artists, the first man involved in the Washington State organization, to bring new enthusiasm for fund-raising to the group.

The New England Quilt Museum (NEQM)

Perhaps the ultimate expression of women's cooperative philanthropy lies in the creation of the New England Quilt Museum. It opened its doors in June 1987 to exhibit traditional and contemporary quilts to visitors in the City of Spindles. The historic mill town today trades to tourists in its historic association with the textile industry.[5]

In 1991 the museum's collection was much bolstered by a generous contribution of thirty-five antique quilts made by Crayola Crayon heiress and quilter, Gail Binney-Winslow. Also a collector of quilts, she had circulated part of her collection nationally through the Smithsonian Institution's SITES program in 1985. The show, "Homage to Amanda," toured in cities throughout the United States. Binney-Winslow made her gift to the New England Quilt Museum, including some of the quilts which had enjoyed national exposure, to a budding institution in her own home territory.

For all her generosity, the new quilt museum was not bankrolled by a major donor. Instead, it was funded by an ambitious alliance of home quilters, united through the New England Quilter's Guild (NEQG). As a member of the Cranberry Quilters Guild of Cape Cod, Binney-Winslow was also allied with the New England Quilters Guild, which formed in 1976 to meet the needs of modern quilters. It was in 1981, eager to view as many quilts as possible and disappointed in the attention that local fine arts museums gave to quilts, that officers of the NEQG voted to embark on the founding of a quilt museum. Six years later, the organization's membership had raised forty-five thousand dollars and opened a museum dedicated to quilts.

The story of the fund-raising is a pains-

taking one. In the absence of an angel coming forward, the membership of the New England Quilter's Guild, two thousand individual quilters and members of fifty guilds (1986–88 figures), pooled their energies to fund an institution in which they believed. Dozens of small quilt clubs, with a handful to a few hundred members, used their meetings not only to trade quilting techniques, sew crib quilts for AIDS babies and battered women's shelters, and attend workshops to improve their technique, but they also devised methods to raise contributions for their museum in Lowell. The Narragansett Bay Quilters sent $7,650 over ten years, by auctioning off quilts that had been donated. Hands Across the Valley Quilters Guild in Amherst, Massachusetts, sent profits from the quilt they raffled at their own quilt show. Other members simply wrote checks. Some groups coaxed other women's voluntary associations to contribute, as when the Connecticut Federation of Women's Clubs were coaxed to contribute $25 at the urging of Connecticut quilters. Some guild members preferred sending needlework to cash. They crafted items for sale at the museum gift shop for museum profit.

The Guild's methods for paying museum bills were and continue to be arduous. A flood from broken pipes in 1991 did not damage the collection but necessitated considerable fund-raising for a move to a more reliable building, at 18 Shattuck Street, where they reopened in July of 1993. Volunteers have provided not only money but hours, to give tours, hang exhibits, organize the library, sell

admissions, and entertain at openings. In return, they have expected a say in the operation of the museum and their mixed messages have contributed to the problem of twelve directors in as many years. But the involvement of thousands of New England women in the founding of the institution provides a foundation of support and sense of ownership and a pool of creativity that is impressive. The effort of so many women who insisted on bringing a traditional art form of women to the attention and recognition of the public overcomes an omission in the professional art world and dignifies the history of women's creative efforts by descendants who carry on the tradition and demand its respect.

Progressive Era, 1900–1920

It is ahistorical to assume that collaborative efforts among philanthropic women are a modern development, but it is not commonly known, even in the museum world, that a large network of women's amateur arts societies began to form and flourish at the turn of this century. The membership carried on many of the same patterns of philanthropy we have just observed in the 1980s. In hundreds of American cities and towns, a dozen or more art-loving neighbors met monthly or even weekly, except in summertime, to study art history for their own edification, acquaint themselves with the work of contemporary artists, and gradually to foster cultural development through founding cultural opportunities in their

communities. The membership was not composed of the richest women, those traditionally associated with philanthropy in America, but of middle-class wives of successful business and professional men in America's big cities and small towns. The women were generally Protestant, white, and economically comfortable, with time, taste, and background to pursue the arts. They came to build and exhibit art collections, create arts centers, and become the earliest supporters of Municipal Art Commissions. In each community, their achievements were small rather than extraordinary, but as a whole, their efforts nationwide to deliver knowledge of and access to women's art are sizable.[6]

Members of amateur arts associations felt entitled, even responsible, for being tastemakers in their communities. Their above-average levels of education and their husband's stature and influence contributed to this attitude. So did their gender, for nineteenth-century "ladies" were thought to be especially sensitive to beauty. In fact, women preferred to cultivate the arts in the company of other women, and they routinely declined opportunities to join coed arts societies. In mixed company, they did not hold executive offices and did not have the clout they enjoyed in woman-only arts groups. In addition, middle-class American women drew on a long tradition of service through voluntary effort. Members' mothers and grandmothers had joined women's societies and auxiliaries for a wide range of purposes, from guilds for the support of benevolent institutions, sewing circles in their churches, and ladies aid societies for war relief.[7]

Most women's arts groups formed initially for the purpose of studying art history. This was true in the Hartford Art Club in Connecticut, the Mankato Art History Club in Minnesota, the Decatur Art Club in Illinois, and the Auburn Art Club in Maine. Sometimes a handful of women met to exchange reviews of exhibitions they had attended or offer a paper they had researched. Sometimes the art enthusiasts were actually a department of a larger woman's club, which also had sub-groups devoted to the study of literature, music, languages, current events, or social problems. The New England Woman's Club in Boston, for example, created an Arts and Crafts Division in 1899, but the club had also formed groups devoted to botany and political economy.[8] Whether they were independent clubs or divisions of larger associations of women, women arts advocates tended to embrace a reverence for the Western canon of old masters. However, they invariably widened their curriculum to include the study of local artists, especially the work of women, and including crafts, notably the art pottery in which women were excelling. When the Hartford Art Club embarked on a study of American art, they devoted separate meetings to the study of women illustrators, women sculptors, women portrait painters, and women miniaturists, and included women in their examination of Connecticut artists.[9] Probably this catholicism arose for a variety of reasons, including the members' lack

of access to the old masters, their local pride, a sense of sisterhood, limited finances for collecting art works, and taste in home decoration.

It was not long before the membership observed the dearth of opportunities for women in the arts and defined it as a problem they should solve. This is hardly surprising, given the reform impulse that gripped many middle-class women of the day, who routinely addressed social problems by creating parks and playgrounds and free health clinics and lobbying for clean milk, mother's pensions, and child labor laws.[10] We can document club efforts to provide as a group, rather than individually, a wide range of support for women artists. Philanthropy in the form of scholarships to women, urban residences for women art students like the Three Arts Clubs in New York, Cincinnati, and Chicago, jobs as instructors at club meetings, exposure through exhibition opportunities, commissions, and donations are among the ways that women in arts clubs facilitated the careers of women artists of their day. Club members did the work that well-heeled philanthropists have done, but accomplished their goals as a group.

These women built a strong record of publicizing women artists by holding exhibitions of their work, even if limited budgets tempered their ambitions. The General Federation of Women's Clubs, claiming a membership of four million in 1926, displayed fifty sculptures by twenty American women at their biennial convention.[11] They also circulated an exhibition of art pottery from potteries in which women were noteworthy, including Rookwood, Overbeck, Newcomb, and Grueby Potteries.[12] Such activities were logical services for member clubs who had long supported the arts with impressive zeal. In 1912, for example, two thousand clubs in the GFWC reported they had offered lectures on art that year and three hundred clubs had held their own exhibitions.[13]

Some women's organizations that existed for purposes far distant from the cause of fine art nevertheless became patrons of the arts to accomplish their work. Patriotic societies of women needed designers for tablets, historical plaques, memorials, markers, and statues of heroes. The Women's Roosevelt Society, for example, sought a bronze medal with the image of Theodore Roosevelt in 1919, and they commissioned Anna Hyatt Huntington to design it. She also created a bronze statue of Sybil Luddington, Revolutionary War heroine, for the Daughters of the American Revolution.

Much of the work that women's clubs commissioned for the decoration of their suburban clubrooms was created by women artists. The Daughters of the American Revolution purchased work by L. Pearl Sanders for Constitution Hall in Washington, D.C., and by Gertrude Vanderbilt Whitney, whose statue was unveiled in 1929 for the courtyard at DAR headquarters. Violet Oakley, renowned for her mural paintings at the Pennsylvania State Capitol Building at Harrisburg, was revered by the Philadelphia Republican Women's

Club, which bought the home of Charlton Yarnall to save Oakley's mural decorations inside it. A bronze fountain by Janet Scudder was commissioned as a memorial shrine to Mrs. E. J. Robinson, president and founder of the Woman's Department Club in Indianapolis, and was placed at the entrance to the main hall of the clubhouse. The Junior Lounge of the American Women's Association building in Manhattan contained a series of murals by Lucile Howard and M. Elizabeth Price. The Wednesday Club in San Diego hired Anna Valentien to produce all of the door plates, hardware, and copper and glass lanterns for their clubhouse. The Daughters of the Republic of Texas commissioned statues of Stephen Austin and Sam Houston by Elisabet Ney, which never adorned their clubrooms, but went to the United States Capitol Building.[14]

Women's groups facilitated public familiarity further when they began, after World War I, to build spacious and luxurious clubhouses with money from government bonds they had acquired to support the war effort. Some of these were designed by women architects. Julia Morgan shaped many California clubhouses, the Berkeley Woman's City Club probably the most admired. Mrs. Minerva P. Nichols designed the New Century Clubhouses in Wilmington and also in Philadelphia. In both Worcester and Lynn, Massachusetts, Josephine Wright Chapman designed the woman's clubhouses. Hazel Wood Waterman designed the Wednesday Club in San Diego and Gertrude Sawyer designed the Junior League Building in Washington, D.C. While these buildings provided meeting rooms for a variety of club functions, including meeting rooms for club business, kitchen and dining areas for club luncheons, and auditoria for speeches and concerts, the new halls additionally offered high-ceiling, elaborately furnished gallery spaces for women's art and reception areas for opening parties. The Des Moines Women's Clubhouse included a separate gallery. Sometimes the exhibits were open only to club members, but frequently the club opened the shows to the general public. These galleries and reception halls lent a luster to the art of women such as that attempted by Wilhelmina Holladay in her modern-day women's art showplace.

The advantages of supporting women's art as a collective enterprise went beyond the increased financial base available to a project supported by hundreds of women. The members now shared a responsibility for the arts projects and enjoyed a sense of ownership of the art. Any club's support also served to ensure wide publicity and thus increase the visibility of the artists. And the work of funding, assembling, hanging, and advertising their art shows gave women lessons in arts administration, skills not much available to them elsewhere. The disadvantages, however, were also apparent. A great number of donors inevitably brought conflicting opinions to each issue and practicality was sometimes lost in the high-flown ambitions of dreamers. In New York City, the National Association of Women

Painters and Sculptors gave up their showplace after five years, undone by the expense and debate over handling the details of clubhouse management. Limits on time, space, collections, and security finally daunted as many project planners as those who succeeded.

Clubwomen's solution to their problems was unsurprising, given their willingness to democratize the canon, broaden public access to the arts, and widen patterns of giving, all goals destined to increase women's role in the arts. They became early champions of government aid to the arts, in the form of Municipal Arts Commissions (MAC). Women were not major players in the first city arts committee in America, the privately funded New York City MAC chartered by the City of New York in 1897, but they soon became major exponents of the idea. The Minnesota Commission was formed in 1903, thanks in large part to pressure from Minnesota's State Federation of Women's Clubs. Members of St. Cloud's Art and History Club, while studying the subject of France, observed the phenomenon of support for the arts by the French government. Determined to emulate this generosity, the group's officers introduced the concept at their district convention in 1898 and won the support of the president of Minnesota's State Federation of Women's Clubs, Mrs. Margaret J. Evans. With the entire federation behind the proposal, Governor Van Sant and the 1903 legislature agreed to establish a state art commission (also known as the State Art Society). The government appropriated two thousand dollars per year to the endeavor. The commission's objects were ambitious: "to advance the interest of the fine arts, to develop the influence of art in education and foster the introduction of art in manufactures." The modest budget of the Minnesota art commission, even supplemented by memberships and donations, would not have permitted appreciable activity had not women's volunteer power fueled the agency. Club-women on the State Art Society Board delivered the unpaid labor that established its lecture service, a traveling exhibition program, the loan of photographs of masterpieces of Western art, and the beginnings of an original art collection. Through the cooperation of the St. Cloud Reading Room Society, the organization initiated an annual exhibition. In 1911, with an increased appropriation of $7,500, the society was able to hire Maurice Irwin Flagg as part-time director to expand the services. This advance did not mean that clubwomen dropped out, however. They lent funds for special projects and in wartime, when state funding collapsed, clubwomen revived the Minnesota State Art Society in 1921. It foundered in 1927, but was again revived in the mid-1940s.[15] Early twentieth century women's efforts to broaden American access to the arts were tenacious, creative, and ambitious. Clubwomen's insistence on informing themselves about women artists of past and present, commissioning work by women artists, and pressing government to enhance public access to art, including that by women, was bold and invaluable.

The forebears of contemporary women's arts philanthropy were no less imaginative than contemporary women in supporting public understanding and respect for women's art. The goals, problems, successes, and limitations they faced seem remarkably constant. In both eras, women arts advocates sought to establish women's art in the public eye, in the face of indifference, hostility, and insufficient resources. Yet their projects reached broadly and they made a place for women's art where there was none before.

1. See Papers of the NMWA in the library of NMWA, Washington, D.C.; Anne Higonnet, "Woman's Place," *Art in America* 76 (July 1988), pp. 127–149; K. Blair's interview with W. Holladay; *National Museum of Women in the Arts* (New York: Harry N. Abrams, 1987); and *American Women Artists, 1830–1930* (Washington, D.C.: National Museum of Women in the Arts, 1987).

2. The first state committees to send a show were Kansas and Colorado in 1987 and the most recent were northern California and southern California in 1994. Texas sent its first show in 1988, Washington State and North Carolina in 1989, Upstate New York in 1990, Arkansas in 1992, and Utah and Tennessee in 1993—only Rhode Island's State Committee has no intention of planning and funding an exhibition to send to the national museum.

3. Twelve came from the Seattle area and three from the eastern part of the state. Exhibitors were Sonja Blomdahl, Rachel Feferman, Lorna Pauley Jordan, Francesca Lacagnina, Solveig Landa, Marilyn Lysohir, Janice Maher, Inge Norgaard, Connie J. Ritchie, Jennifer Stabler-Holland, Sarah Jane Teofanov, Barbara E. Thomas, Liza von Rosenstiel, Linda E. A. Wachtmeister, and Patti Warashina.

4. Pullman, Ellensburg, two sites in Seattle, Yakima, Richland, Ilwaco, Pasco, Everett, and Walla Walla.

5. Carter Houck, "Museums Quilts" *Quilters Newsletter Magazine* (April 1994), pp. 22–23; the complete run of *Compass*, the Newsletter of the New England Quilter's Guild; K. Blair's interviews with Marjorie Dannis, Susan Raban, Gail Binney-Stiles, Una Baxer; and the Papers of the New England Quilt Museum in the library of the Museum in Lowell, Massachusetts.

6. Karen J. Blair, *The Torchbearers: Women and Their Amateur Arts Associations in America, 1890–1930* (Bloomington: Indiana University Press, 1994), chapter 4.

7. Barbara Berg, *The Remembered Gate: Origins of American Feminism, The Woman and the City, 1800–1860* (New York: Oxford University Press, 1978); Paula Baker, "Domestication in Politics: Women and American Political Society, 1780–1920," *American Historical Review* 89 (June 1984), pp. 620–647.

8. Massachusetts State Federation of Women's Club, *Progress and Achievement: A History of the Massachusetts State Federation of Women's Clubs, 1839–1962* (Lexington: Massachusetts State Federation of Women's Clubs, 1962); Jane Cunningham Croly, *The History of the Woman's Club Movement in America* (New York: Henry G. Allen, 1898).

9. Hartford Art Club Yearbooks, 1921–23 (Hartford: Stowe-Day Foundation).

10. Karen J. Blair, *The Clubwoman as Feminist: True Womanhood Redefined, 1868–1914* (New York: Holmes and Meier, 1980), chapter 6.

11. Rose V. S. Berry, "The Spirit of Art," *Eighteenth Biennial Proceedings* (Washington, D.C.: General Federation of Women's Clubs, 1926), pp. 270–273. These included the work of Brenda Putnam, Edith Barretto Parsons, Bessie Potter Vonnoh, Grace Mott Johnson, Laura Cardin Fraser, Anna Vaughn Hyatt Huntington, Harriett Payne Bingham, and Harriett Frishmuth.

12. "Art Department," *General Federation Magazine* 12 (April 1914), pp. 9–10.

13. Other networks with women art lovers similarly supported the accomplishments of women. When the Friends of the Arts in Pittsburgh public schools acquired 134 works of art to hang in the classrooms, 47 of those works were by women (see Catherine Kaiser, "Those One Hundred Friends," *Carnegie Magazine* [September/October 1984], pp. 22–24). In McPherson, Kansas, the community featured Anna Keener's painting *Mountain Ranch* (see "An Exhibition in a Kansas High School," *American Magazine of Art* 9 [January 1918], pp. 111–113). The Woman's Art Club of Cincinnati bought a painting by Mary Spencer in 1912, a gift for the Cincinnati Art Museum. In Richmond, Indiana, the woman-run Art Association purchased Indiana art for the high school art gallery, including sculpture by Janet Scudder and pottery by the Overbeck Sisters alongside the work of Hoosier-identified male artists like William Merritt Chase.

14. See *American Art Annual* 26 (1929), p. 18; *American Art Annual* 24 (1927), p. 17; *American Art Annual* 25 (1928), p. 18; *American Art Annual* 28 (1931), p. 18; Vernon Loggins, "Elisabet Ney," in *Notable American Women*, ed. Edward T. James, et al., (Cambridge: Harvard University Press, 1971), vol. 2, pp. 623–625; Bride Neill Taylor, *Elisabet Ney, Sculptor* (Austin: Thomas F. Taylor, 1938), pp. 75–78. Clubs also worked to improve the knowledge of the community. The General Federation's Art Director, Rose Berry, urged clubwomen to study the work of American women painters Mary Cassatt, Elizabeth Bourse, Cecilia Beaux, Helen Maria Turner, Lilian Westcott Hale, Jean McLane, Gertrude Fiske, Lillian Conth, Anna Fisher, Felicia W. Howell, M. DeNeale Morgan, Helen Dunlop, Marie Danforth Page, Alice Kent Stoddard, Ellen Emmet Rand, Lydia Field Emmet, Violet Oakley, Dorothy Ochtman, Evelyn Withrow, Pauline Palmer, Mary Foote, Jane Peterson, Johanna K. Hailman, and Marie Oberteufer and American sculptors Harriett Frishmuth, Anna Vaughn Hyatt Huntington, Malvina Hoffman, Edith Barretto Parsons, Bessie Potter Vonnoh, Laura Cardin Fraser, Brenda Putnam, Evelyn Beatrice Longman, Beatrice Fenton, Gertrude Vanderbilt Whitney, Grace Talbot, Margaret French Cresson, Abastenia Eberle, and Lucy Perkins Ripley (see *Scribner's Magazine* 83 [June 1928], pp. 792 g, h, and 76). The Federation's 1911 edition identified numerous examples of women's art in public spaces, including Southern Womanhood statue in Atlanta by Belle Kinsey; statues of Lady Macbeth, General Albert Sidney Johnston, Sam Houston, and Stephen Austin in Austin by Elisabet Ney; Leif Ericson by Anne Whitney in Boston; Inspiration statue at the front of the Buffalo Historical Building by Gertrude (Mrs. Harry Payne) Whitney; Mother Bickerdyke statue

in Galesburg, Illinois, by Mrs. Theodore Ruggles Kitson; Daniel Boone statue in Louisville by Enid Yandell; Soldiers' Monument in Newburyport, Massachusetts, by Sally James Farnsham; Carrie Brown Bagnotti Memorial Fountain in Providence, Rhode Island, by Enid Yandell; statue of Admiral Esek Hopkins in Providence by Mrs. Theodore R. Kitson; Beatrice Cenci by Harriet Hosmer and Awakening of Spring by Clara Pfeiffer Garrett in St. Louis; Carnegie Library designed by Julia Morgan in Seminary Park, California; Hamilton S. White Memorial in Syracuse by Gail Sherman Corbett; Admiral David Farragut in Washington, D.C., by Mrs. V. R. Hoxie; bust of Alice Freeman Palmer in Wellesley, Massachusetts, by Anne Whitney; bas relief portrait in courthouse by Mar Stickney in Woodstock, Vermont; and the woman's clubhouse designed by architect Josephine Wright Chapman in Worcester, Massachusetts (see *Mrs. Everett W. Pattison, Handbook of Art in Our Own Country* [St. Louis: General Federation of Women's Clubs, 1908 and 1911]).

15. See Mrs. Everett W. Pattison, "Art and the Women's Clubs," *Federation Bulletin* 7 (May 1909), pp. 38–40; GFWC, *Eighth Biennial Proceedings* (1906), p. 106; Staff of the Minnesota Historical Society, "Brief History of the Minnesota State Art Society," and "Report of the Minnesota State Art Society, 1903–4," both in Minnesota Historical Society (St. Paul: Minnesota State Historical Society, ca. 1949); Mrs. Phelps Wyman, "State Art Society of Minnesota," *American City* 7 (August 1912), pp. 142–143.

NEVER COMPLAIN, NEVER EXPLAIN: ELSIE DE WOLFE AND THE ART OF SOCIAL CHANGE

David Park Curry
Virginia Museum of Fine Arts

"The fact was, you could hardly tell a lady now from an actress."

—Edith Wharton, *The Buccaneers*[1]

Elsie de Wolfe's long life—from 1865 to 1950—encompasses an extraordinary period of technological, economic, and social change in the United States. Whether languidly lounging in the overupholstered Turkish Corner of the Aesthetic Movement (fig. 1), or about to race away in a streamlined jazz age airplane, de Wolfe helped to establish fresh modes of cultural leadership in America by taking advantage of the commercialization of leisure to blur the boundaries between public and private spaces. Ignoring strictures that stymied many others of her sex, de Wolfe chose as her starting point "the home"—that sacred ground which both defined and limited Victorian women. Her conduct offered an expanding definition of decorum, for in Elsie de Wolfe as paradigm, we sense a professional life lived as a continuous performance.

Details of de Wolfe's varied activities—as both amateur and professional actress, interior decorator, art advisor, and high-flying socialite—might read almost as soap opera. However, when condensed into a single-minded quest for personal independence, de Wolfe's career can be seen as a nexus, linking complex cultural hungers that are also expressed in American literature and painting.

In 1897 John Singer Sargent painted Mr. and Mrs. Isaac Newton Phelps Stokes wearing casual dress (fig. 2). The young couple worried a bit over how the portrait would be received by their circle of friends and acquaintances, who numbered among the "400" of New York society. But Phelps Stokes and his bride were also aware that American cultural leadership was in flux. Socially conscious, Isaac served as an architect for New York's University Settlement, a philanthropic organization offering medical, educational, and social support to immigrants. His wife, as the president of the New York Kindergarten Association, aimed to socialize "children whose earliest education would otherwise be received on the streets."[2]

The couple selected a fashionable painter but accepted an unconventional composition—with Mr. Phelps Stokes

Fig. 1. Elsie de Wolfe in a Turkish Corner in the Irving House, New York, 1896. Photograph, Museum of the City of New York.

relegated to the background and his wife out front wearing the sort of sports clothes popularized in the Gibson Girl image.[3] Such choices reflect not only the dynamics of social change, but also a significant shift in permissible behavior for polite society. Despite their hesitations over the picture's unconventionality, the Phelps Stokeses were prominent enough to make such choices with a degree of confidence. But what did the simple folk do? How were America's newly affluent supposed to know what was tasteful? In orchestrating their social performances, to be staged in front of an ever-critical gallery of the already-arrived, how were ingenues to come off as ladies rather than actresses?

Fortunately, various guides were available to the newly affluent, indicating what was tasteful. Among them Elsie de Wolfe's *The House in Good Taste* (1913) proved among the most enduring of the twentieth century. In it, the former actress who subsequently would become a titled lady established a lighthearted yet upscale combination of French antiques, modern reproductions, and

English chintz that has remained in vogue to this day.[4]

For the book's signed frontispiece photograph, the author leans casually on the mantle (fig. 3). Although she is draped in a drop-dead fur, her book is both practical and purposeful, standing in sharp contradistinction to the somewhat elitist *Decoration of Houses* written by Edith Wharton and Ogden Codman in 1902.[5] Clearly, de Wolfe had studied the earlier text, bolstered with references to "the best models," meaning "buildings erected in Italy after the beginning of the sixteenth century, and in other European countries after the full assimilation of the Italian influence."[6] However, de Wolfe abandoned art historical propinquity for "suitability, simplicity and proportion."[7] That these were "self-taught lessons" suited an audience comprised chiefly of the self-made. De Wolfe was less concerned with authenticity, provenance, and rigidly defined use of spaces than with physical comfort and visual effect at a time when the excesses of the Gilded Age as well as the moralizing of both the Aesthetic and the Arts-and-Crafts movements were being called into question.

By the time de Wolfe put pen to paper, America's wrenching transformation from an agrarian economy to an industrialized, urban society marked by confidence and doubt, excitement and trepidation, was well under way. Like most popularizers, de Wolfe did not invent everything she advocated. Rather, she kept a well-manicured finger on society's pulse, nursing friends

Fig. 2. John Singer Sargent, *Mr. and Mrs. I. N. Phelps Stokes*, 1897, oil on canvas. The Metropolitan Museum of Art, New York, Bequest of Edith Minturn Phelps Stokes (Mrs. I. N.), 1938, 38.104.

and clients along to greater tastefulness. It should be understood that de Wolfe advised the same middle class audience that had been addressed earlier by the commercially minded self-help books of the 1870s and 1880s, such as *Suggestions for House Decoration in Painting, Woodwork and Furniture* (London, 1876), whose British authors asserted:

> *It is middle-class people specially who require the aid of a cultivated and yet not extravagant decorator who may help them to blend the fittings of their now incongruous rooms into a pleasant and harmonious habitation.*[8]

54

That the American Clarence Cooke's more memorable title, *What Shall We Do With Our Walls?* (New York, 1880), was published by a wallpaper manufacturer underscores at once the dilemma: anxious consumers beset by seemingly endless choices yet fearful of errors in taste that might compromise hard won social status; and the solution: commercial enterprise willing to assist them.

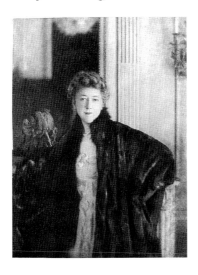

Fig. 3. Elsie de Wolfe, frontispiece to *The House in Good Taste* (New York, 1913).

As the nineteenth century drew to a close, various journals and periodicals took up taste-making. Always a clever business woman, de Wolfe addressed a ready-made audience. Parts of her book first appeared as a series of articles commissioned by Theodore Dreiser, then editor of *The Delineator*. A second set of articles was published in *The Ladies' Home Journal*.[9] De Wolfe's timing was impeccable, for her uncomplicated approach to simplified decoration fol-

lowed on the heels of anti-clutter exhortations to the modern housewife that had filled editorial pages for years. "Do not hesitate to store ornaments," a typical *House Beautiful* admonishment, anticipates by nearly a decade de Wolfe's reassuring promise that her readers "will never again be guilty of the errors of meaningless magnificence."[10] De Wolfe thus built on the moralistic cornerstone of Arts-and-Crafts theory—simplicity—even as she rejected the commercial products of that movement—florid Morris wallpapers and sturdy mission furniture—as too plebian. Simultaneously, her text subtly undermines another favorite tenet of Arts-and-Crafts theorists: the importance of earnest hand labor. De Wolfe did not labor over these pages—she used a ghost writer.[11] Her's rapidly became a "celebrity look," associated with glamorous gatherings in New York, Versailles, and Paris, where pillars of society—the Astors, the Hewitts, the Morgans, even Isabella Stewart Gardner—mingled with glittering opera stars Emma Calvé and Nellie Melba, actresses Sarah Bernhardt, Ellen Terry, Ethel Barrymore, and Maxine Elliott, aesthete Oscar Wilde, historian Henry Adams, and others. "I went to the Marbury salon," wrote Henry Adams,

> *and found myself in a mad cyclone of people. Miss Marbury and Miss de Wolfe received me with tender embraces, but I was struck blind by the brilliancy of their world. They are grand and universal . . . I had to chatter as one of the wicked, and got barely a whisper of business.*[12]

De Wolfe's look was fresh, easy to recognize, easy to imitate, a clever combination of the real and the ideal as de Wolfe's biographer points out.[13] De Wolfe presented her formulae in a chatty offhand first-person manner that offered the user a sense of personal association with stardom that anticipates exchanges between today's talk show hosts and their guests, not to mention article after article in the glossy "shelter magazines" of our own time.

De Wolfe was alert to the beautiful early on, recounting a tale of decoration gone wrong that rivals Oscar Wilde in combining seeming frivolity with lasting purpose:

> *The farthest away thing that I can remember of my childhood is starting off for school one day bright and happy because the family sitting room was to be done up afresh. All through the school hours my mind was full of how beautiful that room was going to be. When I returned and saw it I burst into bitterest tears, much to the amazement of my father and mother, who could not imagine the cause of my grief. I finally sobbed out that the room was <u>ugly</u>—UGLY—and that my heart was breaking with the disappointment of it . . . I think that this intense love of everything beautiful . . . has been the dominant trait all through my life.[14]*

Clearly, she took to heart the Aesthetic Movement's primary theme—the pursuit of beauty—although she rejected the style itself.

Fig. 4. John Singer Sargent, *Isabella Stewart Gardner*, 1888, oil on canvas. Courtesy of the Isabella Stewart Gardner Museum, Boston.

De Wolfe herself was not without a paradigm—she greatly admired Isabella Stewart Gardner. "Her brain was far ahead of her time, and she had tremendous courage in advancing her ideas," de Wolfe later wrote of "Mrs. Jack," whose theatricality, extravagant taste, and sumptuous collections well fitted her as a role model for an aspiring

amateur actress striving to become a polished professional arbiter of taste.[15] Each lady, bred by a respectable New York family, flouted convention yet climbed to the top of the social tree.

On her occasional visits to Boston, de Wolfe was impressed by Isabella Gardner's splendid, art-encrusted palace on the Fenway, and eventually ended up with her own palace of sorts, the Villa Trianon near Versailles. Following a session with Mrs. Jack in 1907, Elsie wrote:

> I shut my eyes close to shut in all the beauty of . . . your wonderful things & shut out all the banalité and sordidness of our incredible present. You have accomplished a great and beautiful thing which will bear fruit in the great artistic advancement of our waiting people.[16]

Each lady understood that an audience awaited them. The methods each pursued in her rise to eminence and cultural leadership sometimes overlap, sometimes differ, reflecting larger social shifts as endlessly retailed by a progression of journalists and novelists, as well as impressionist and realist painters.

Just as Sargent's well-known portrait of Isabella Gardner presents the Boston collector as an icon (fig. 4), so did Cecil Beaton later stage Elsie de Wolfe, festooned with sumptuous pearls and silhouetted against luxurious fabric. Recalling Sargent's work, de Wolfe later commented, "Instead of feet he gave her two tiny hooves set close together."[17] De Wolfe's own portrait may well be an homage to a devilish kindred spirit. Granted, "Queen Isabella," as de Wolfe

fondly referred to Boston's most famous patron, wore bigger pearls and more of them. On the other hand, Elsie neither inherited nor married money—she made her own fortune, remarking candidly, "I went upon the stage because I loathe poverty."[18] Working primarily in New York, with sojourns in London, Paris, and eventually Los Angeles, de Wolfe's behavior was shaped by the theater as both vehicle for advancement and platform for expression. The stage gave her the freedom she needed, and her later work as interior decorator and artistic advisor would evolve from it.

De Wolfe's choices of life companions, including not only her long relationship with theatrical agent Elizabeth Marbury but also a marriage of convenience to Sir Charles Mendl, suggest that she was willing to step outside conventional mores. However, like Isabella

Fig. 5. John Sloan, *Chinese Restaurant*, 1909, oil on canvas. Memorial Art Gallery of the University of Rochester, New York, Marion Stratton Gould Fund, 51.12.

Gardner, de Wolfe was dextrous at stretching, but not quite breaking, the social envelope.

Not going *too* far was also a primary characteristic of American painting and literature at this time. John Sloan's *Chinese Restaurant* carries the point (fig. 5). The artist himself implied that the girl in a red-feathered hat is a hooker.[19] Yet, unlike numerous cafe, nightclub, and brothel scenes by Edgar Degas, with their chill focus upon sordid transactions, Sloan's young woman dispenses good cheer, feeding both her boyfriend and the resident cat, while amusing two male diners—and by extension, us. A graceful chain of hands links the characters in this essentially good natured little performance, which transpires below bright red Chinese characters wishing us good fortune.

Like other entreprenurial souls during this period—including painters and writers—de Wolfe clearly recognized the self-conscious nature of art as performance. Surviving nearly a century of turbulent change, de Wolfe kept herself on the cutting edge with energy, imagination, and humor. Long after she had ceased being an actress, de Wolfe continued to be a performer: a ceiling decoration for her French villa captures her leaping the Atlantic, followed by one in her boundless succession of lap dogs (fig. 6).

De Wolfe's carefree posture here is so saucy and unladylike that it is rather hard to believe that Mary Cassatt's *Woman in Black at the Opera*, painted more than four decades earlier, recorded behavior that was once equally indecorous (fig. 7).

Cassatt's self-possessed woman stares, not at the stage, but at an unseen occupant of another box. Meanwhile, a portly man leans out of his box to ogle the woman in black. Not the opera itself but the audience was now of interest, for the arts of the past, whether music or painting or architecture, were in service of the present. A decade after Cassatt painted the *Woman in Black at the Opera*, de Wolfe paid a visit to the

Fig. 6. A. Drian, ceiling painting, oil on canvas. Elsie de Wolfe Foundation.

Chateau at Blois, telling the readers of *The Cosmopolitan* that it made her "think of nothing so much as the rows of boxes at the Metropolitan Opera House, and which needed only a few of the 400 and their apparelling to be complete."[20]

Acceptable behaviour was in flux. By the turn of the century, *looking*—at fine

art, at displays of technology or consumer goods, at public performances, and, of course, at one another—had become an established practice. "Spectator sports" ranged far beyond the race track and the boxing ring. Cassatt composed *Woman in Black at the Opera* without a foreground, automatically placing the viewer within the woman's opera box. Completely absorbed in her own scrutiny, the elegant spectator takes no notice, as if we had entered uninvited. Here we see how American painters had begun to follow French precedent, adopting a variety of established artistic devices that involved viewers in their compositions by making them part of the painted audience captured on canvas. Cassatt kept a low personal profile, yet other painters—James McNeill Whistler notorious among them—actively worked to keep themselves in the public eye.[21] Similarly, de Wolfe's publicity-seeking antics kept the public spotlight focused on her, just as her acting involved the audience with itself. In 1901, her aptly named play, *The Way of the World*, seemed:

> . . . not so much a dramatic entertainment as a social function. Any well-ordered comment upon it must take cognizance of the audience as well as of the mummers who perform on the far side of the footlights. [The audience is] as much a part of it as the stage setting, and the result of their presence is that the five-act drama and its four intermissions and final curtain form a continuous performance the like of which New York has never seen before.[22]

Journalists regularly used theatrical figures of speech to characterize the modern city. One wrote in 1909, "The city sleeps for a few hours . . . like a weary columbine at the theater wing, in all its paint and spangles, expecting its call to 'go on' at any moment."[23] To be a participant in the modern city was to be cast in a role, filling at least a bit part or perhaps even taking a star turn. This issue was understood by architects who

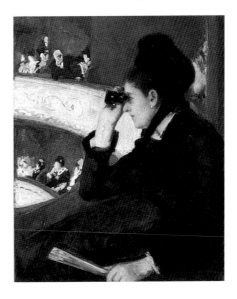

Fig. 7. Mary Cassatt, *Woman in Black at the Opera*, 1879, oil on canvas. Museum of Fine Arts, Boston, The Hayden Collection, 10.35.

created elaborate public spaces to let hotel, restaurant, and theater patrons see and be seen. Resplendent facades, clad in the ornament of the long ago and the far away but festooned with the latest electric lights, spilled "their invitations in streams of golden light across the sidewalk," as Mariana Griswold Van Rensselaer observed in 1895, about the

Fig. 8. William Glackens, *Chez Mouquin*, 1905, oil on canvas. The Art Institute of Chicago, Friends of American Art, 1925.295.

time Elsie de Wolfe, still a budding actress, was being photographed regularly for publicity purposes.[24]

The focus of architects, decorators, journalists, novelists, painters, and actors —performers all—frequently coincided. In the city's theaters, opulent lobbies and parterre boxes framed one part of the audience for the rest. Refreshing roof gardens and private dining clubs at the tops of skyscrapers took in views of the metropolis even as they provided sanctuary from it, offering spectacles of the city that complemented the spectacles onstage. Gilt-framed mirrors encrusted the walls of glittering hotel lobbies, lobster palaces, and drinking establishments, reflecting the city's players upon themselves.

William Glackens's *Chez Mouquin*, painted in 1905, depicts a restaurateur,

James B. Moore, sitting with his eyes averted from us as he lifts a small glass of whiskey (fig. 8). Turned away from him, his companion wears an enigmatic expression while touching the stem of a well-filled cocktail glass. Like the open pink rose in the little tabletop still life, the nameless woman is in full bloom. Behind the Manet-like roses a suggestive bottle stands tall. Remarking upon "that still life which makes life at Mouquin's far from still," one contemporary newspaper critic announced "it is the moment of liqueurs and soft asides."[25] An independently wealthy bon vivant, Moore was noted in artistic and literary circles for his amorous peccadilloes involving a series of young women whom he referred to as his daughters.

After describing such alluring nightlife possibilities in seductive detail, the literary realist Theodore Dreiser warned the readers of *Sister Carrie* in 1900:

> *so long as . . . the human heart views this as the one desirable realm which it must attain, so long . . . will this remain the realm of greatness. So long, also, will the atmosphere . . . work its desperate results in the soul of man. It is like a chemical reagent.*[26]

Like Elsie de Wolfe, Dreiser's lead character serves first as an amateur, then a professional actress. Unlike Elsie, whose thespian skills were essentially limited to the role of clotheshorse for the latest Paris fashions, Carrie becomes an acclaimed performer. Yet, at the end of his tale, the moralistic and ever-wordy Dreiser leaves Carrie unfulfilled, for she has been seduced in cozy restaurants on

the order of Chez Mouquin and must be punished:

> *Know, then, that for you is neither surfeit nor content. In your rocking chair, by your window, dreaming, shall you long for beauty.*[27]

One in the host of de Wolfe's publicity photographs shows her seated in a rocker. But de Wolfe didn't just rock and yearn for beauty. She went out and earned it. "I am eminently practical and don't dream of obtaining things for which I am not willing to work," de Wolfe crisply told the readers of *Metropolitan Magazine* in 1901.[28]

Women had been working in theater for over two hundred years. Frequently, turn-of-the-century photographic theater cards, including some of de Wolfe, replicate the frankly casual poses of actress portraits from previous centuries, such as Sir Joshua Reynolds's depiction of Frances Barton Abington in the role of "Miss Prue" in Congreve's *Love for Love* (figs. 9, 10). Mrs. Abington began her career as the tawdry "Nosegay Fan" who sold more than just flowers in the streets of London before eventually marrying advantageously and earning fame and fortune as a multilingual stage star who dazzled London audiences of the 1760s by portraying Lady Teazle in Sheridan's *School for Scandal.*[29]

That the theater has long provided a platform for women to advance themselves regularly provokes the dismay of social commentators. As one observed sardonically in 1893, when Elsie de Wolfe was just establishing herself on the stage:

Fig. 9. Elsie de Wolfe, Theater Card, 1890s. Museum of the City of New York.

Fig. 10. Sir Joshua Reynolds, *Mrs. Abington as Miss Prue in Congreve's "Love for Love,"* 1771, oil on canvas. Yale Center for British Art, Paul Mellon Collection.

*That cunning prestidigitator, mis-
called Progress, laughs in its sleeve
as it leads the girl bachelor to the
footlights and introduces her as the
woman of the future.*[30]

De Wolfe, like Mrs. Abington, would
eventually play the role of Lady Teazle,
but she remained fundamentally untar-
nished by the breath of scandal. Viewed
by contemporaries as independent wom-
en of the future, Elsie and her friends,
including her lover, the theatrical agent
Elizabeth Marbury, were known in New
York's polite society as "the bachelors."
Their personal relationships remained
strictly private. The roles Elsie took
on stage, such as Mrs. Croyden, the
maligned but quite faithful wife of a ris-
ing politician in Clyde Fitch's *The Way
of the World*, tended to reinforce widely
accepted cultural mores. At the end of
the play, a morally vindicated and mod-
ishly gowned Mrs. Croyden appears at
the christening of her child before accom-
panying her husband to Madison Square
Garden for his acceptance speech as the
new governor.

Noting that American theater had
become a profitable social paradigm
"where the arts of rendering merely
human actresses into living embodi-
ments of feminine perfection were prac-
ticed at the most expert and profitable
levels for mass instruction and emula-
tion," historian Kim Marra recently
analyzed *The Way of the World*, a play
produced specifically as a vehicle for de
Wolfe.[31] Readers of *Harper's Weekly* were
assured that the play provided its audi-
ence with "more than one's money's

Fig. 11. Scene from *The Way of the World*, 1901.
Theater Collection, Museum of the City of
New York.

worth in instruction, not to mention the
mere matter of diversion." Another jour-
nalist commented, "Middle-class people
can, for the small price of admission,
learn how the upper ten enter their
automobiles and serve five o'clock tea."[32]
That there was some sense of need for
such a paradigm is evident in the lament
of Richard Mansfield in his address to
the students at the American Academy
of the Dramatic Arts:

*It is quite time that people with the
manners of, let us say, a sea cook,
should cease from disporting them-
selves on the stage, especially in
society dramas.*[33]

Intense realism governed both the
casting and the scenery of the produc-
tion—"A Mirror of Society" as one critic
put it.[34] The curtain went up on a lush,
sunlit Central Park scene enhanced by
the chirping of birds. De Wolfe herself
chose the furniture and appointments
that decorated the interior scenes. The
play's devotion to realism included an
automobile (fig. 11), not unlike the

one de Wolfe and Marbury actually used in France.[35] A chauffeur joined the cast after a rehearsal during which several musicians in the pit came close to death as de Wolfe nearly drove off the stage. However, despite de Wolfe's driving skills, this is the first time that a beautiful woman appears in connection with a desirable automobile—as Marra points out, one of the longest lasting ploys in American advertising.[36]

Fig. 12. John Sloan, *Gray and Brass*, 1907, oil on canvas. Collection of Mr. and Mrs. Arthur G. Altschul.

Relentlessly realistic staging in some of New York's theaters coincides with the emergence of American realism in painting circles dominated by Robert Henri, John Sloan, and others who shortly would be lumped together as "the Ashcan school." Sloan's mordant canvas, *Grey and Brass*, serves to remind us of the mixed feelings that the products of new technology regularly engendered (fig. 12). Sarcastically, perhaps enviously, Sloan dismissed this cartoonish vehicle as a "brass-trimmed, snob" automobile laden with the "nouveau riche."[37]

Socially instructive plays on the New York stage carry on in the vein of late Victorian comedies of manners. But there are also parallels with other contemporary urban entertainments. For example, new restaurants for the middle classes imitated such elite establishments as Delmonico's, where elegant meals epitomized New York's upper-class social life by the mid 1880s:

> *Many persons . . . learned for the first time at Delmonico's that dinner was not merely an ingestion, but an observance . . . When we compare the commensualities of our country before the Delmonico period . . . with our condition in respect of dinner now, and think how large share of the difference is due to Delmonico's, we shall not think it extravagant to call Delmonico's an agency of civilization.*[38]

Supping at Sherry's with her current lover, Dreiser's Sister Carrie observes a host of instructive details that actually did make this restaurant the leading haunt of New York's young smart set in the early 1900s. Dreiser chronicles "the white shirt fronts of the gentlemen, the bright costumes of the ladies, diamonds, jewels, fine feathers . . ." emphasizing that "the air of assurance and dignity about it all was exceedingly noticeable to the novitiate."[39]

But de Wolfe's stage performances, coupled with the power of modern journalism, went beyond other urban entertainments by reinforcing role modeling

Fig. 13. Frank Benson, *Lady Trying on a Hat*
(*The Black Hat*), 1904, oil on canvas. Museum of
Art, Rhode Island School of Design, Providence,
Gift of Walter Callender, Henry D. Sharpe,
Howard L. Clark, William Gammell, and Isaac
C. Bates, 06.002.

Fig. 14. Everett Shinn, *Footlight Flirtation*,
1912, oil on canvas. Collection of Mr. and Mrs.
Arthur G. Altschul.

with passive window-shopping—product
endorsement was part of the show. At
this point in her career, haute couture

French clothing was the most important
product that Elsie de Wolfe animated for
her theater audiences. She made flowing
gowns by Paquin and Worth as desirable
as *The Black Hat*, rendered by Benson in
seductive layers of rich, thick pigment
(fig. 13). Lavish, if not to say worshipful,
descriptions of individual gowns in the
fashion press reiterated the details of the
costumes, noting:

> *Their wearer may, it is safe to assert,*
> *step from the stage to a ball-room or*
> *drawing-room with perfect impunity.*
> *Nothing in the style or color or gen-*
> *eral effect of her gowns is dependent*
> *upon the footlights.*[40]

The producer Charles Frohman, who
paid for these gowns, crowed, "Fifth
Avenue looks to the stage for its ideas in
modes and follows those ideas implicitly,
almost blindly . . . Society is about five
months behind the stage in the correct-
ness of its apparel."[41] The painter Everett
Shinn, whose career de Wolfe conscien-
tiously promoted, explores this issue on
canvas in *A Footlight Flirtation* (fig. 14),
using a parasol tip to link the fashion-
ably-clad actress on stage to a woman in
the audience.[42]

Of course, part of the point of high
fashion is that it can never be attained
entirely by the many. After visiting the
annual November horse show in 1899,
"Lady Modish," the fashion reporter for
New York's *Town Topics*, sniped:

> *The amount of ill-matched and*
> *grubby-looking chinchilla on putty-*
> *toned frocks upon pasty-faced, fading*
> *women is enough to make the*
> *woman who has color and youth and*

64

*can wear really handsome chin-
chilla, bury her face in her muff and
baptize it with her tears. Elsie de
Wolfe must be amused to note how
many women are wearing reflections
of that clinging blue crepe with the
chinchilla and silver embellishments
which she exhibited in the muff flir-
tation scene as long ago as weepy*
Catherine *held the boards.*[43]

No matter how inspiring de Wolfe
may have been as a clotheshorse and
role model, she still had to contend with
serious newspaper criticism. Studies of
theater performers' hard lives, driven by
the demand for continuous performance,
and touched by the ever-present ethos of
the sad clown, remind us just how unfor-
giving the theater world actually was, an
issue made clear in turn-of-the-century
pictures, such as *Hammerstein's Roof
Garden* (ca. 1901, Whitney Museum of
American Art), where William Glackens
captures a daring female performer teter-
ing precariously on a tenuous highwire
stretched above a gaping crowd. A little
pastel by Shinn, now in a private collec-
tion, depicts a lone, harshly lit vaudevil-
lian getting the hook. De Wolfe's acting
career was equally precarious. *The Way
of the World*, her most ambitious play,
was intended to launch her independent
company, but it failed from a fiscal stand-
point, a victim of the competitive eco-
nomics of the New York theater world,
not to mention de Wolfe's limited acting
talents.[44] One reviewer noted de Wolfe's
"frocks all through her new play are as
delightful as the first three acts of that
play, and that is saying a great deal.

Unlike the drama, there is, sartorially, no
let up."[45] Other reviews were far less
kind. Having made the transition from
amateur to professional actress, de Wolfe
was still encountering the same offhand
critical dismissal she received as a young
socialite in amateur productions: "She
was splendid in the second dress."[46]

When we recall how, during the
1770s, London fashion was "set by Mrs.
Abington's stage costumes, and her con-
tract with Drury Lane theatre in 1781
stipulated an annual allowance of 500
pounds for her wardrobe," we see how
often the patterns of modern life in turn-
of-the-century America have their ante-
cedents in previous centuries.[47] It was by
turning to the past that de Wolfe would
continue to make her mark on the future,
becoming an interior decorator and col-
lections advisor, endorsing through her
own example—her "life-style" in today's
terms—not only fashionable dress, but
also selected art, furniture, and decora-
tions. She had already laid the ground-
work, writing travel articles for the pop-
ular press, doing costume and set research
for historical dramas, and spending
instructive summers in France where
she enjoyed the society and the tutelage
of collectors, historians, and connois-
seurs including Lady Minna Anglesey,
the Baron Pichon, Pierre de Nolhac,
and Comte Robert de Montesquiou-
Fezensac.[48]

Sensible to the core, de Wolfe ended
her professional stage career in 1904, at
the age of thirty-nine, although she still
indulged in private vaudevillian specta-
cles, such as an extravagant circus ball

held at her French villa in 1938.[49] In leaving, de Wolfe took with her both an avid following and a saleable skill. For New Yorkers, not only opulent gowns but also elaborate stage sets served as models for emulation. Lavinia Hart, a society columnist, described the interior scenery of *The Way of the World*:

> We would do away with "props" and have people act in real scenes from life—in rooms that might really be lived in, with hangings of velvet, not of paint; with statuary of marble, not of plaster; with carpets into which correctly slippered feet may sink instead of painted boards; with desks and tables that are real, not made of papier-mache, and with flowers not made of paper or wax, but fresh-cut and dewey, whose scent gets over the footlights and helps make a real illusion real . . . Miss de Wolfe's Mrs. Croyden is a character with whom we are all familiar, and Miss de Wolfe presents her to us just like the Mrs. Croydon on our visiting lists.[50]

By creating live-in stage sets that made illusions real, de Wolfe subsumed the general concept of public interior spaces where patrons would see and be seen. In 1905, she landed her first important commission: creating then-unexpectedly casual interiors for the Colony Club which Stanford White had designed as a gathering spot for well-born New York ladies in America's first large-scale private clubhouse for women.[51]

The Colony Club received a great deal of press coverage, becoming a model for women's clubhouses there-after. Commentators emphasize that it had "the appearance of a comfortable and dignified private residence, rather than that of a clubhouse."[52] The patrician clientele chose the device of Diane de Poitiers as their club crest. However, Stanford White designed the building in the Colonial Revival style. Put up in 1905–06 at 120 Madison Avenue, just north of 30th Street, the club served as a power-base for:

> leading women in the business, the social, the artistic, the literary [and] the theatrical worlds [giving] them a club home where they can enjoy social pleasures . . . athletic privileges . . . a literary and artistic center.[53]

A seemingly jocular children's illustration by L. Frank Baum suggests just how

Fig. 15. William W. Denslow. Illustration for L. Frank Baum's *Father Goose* (Chicago, 1899). Courtesy, Richmond Public Library.

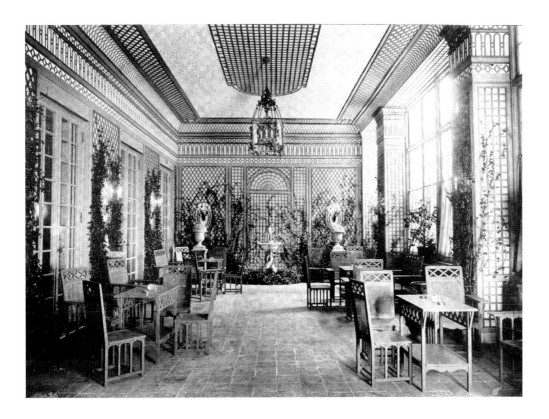

Fig. 16. "The Trellis Room in the Colony Club," Elsie de Wolfe's *The House in Good Taste* (New York, 1913).

threatening to established values of home and family such a power base might seem (fig. 15).

A friend of Stanford White, Elsie de Wolfe got the contract to decorate this important interior. It also did not hurt that many founding club members were old friends and that her lover, Elizabeth Marbury, chaired the House Committee.[54] Significantly for de Wolfe's future career:

The pleasing effect of [her] simple and restful ornamentation has made more than one visitor decide to go home and [incinerate] all the indifferent and mediocre pictures and bric-a-brac cumbering her domicile, and to start fresh with humility in the heart and nothing but hope on the walls.[55]

Among her most familiar, most often reproduced and frequently copied innovations was a trellis room "whose vine-clad walls, fountain, and garden vases give it a pleasant air of outdoor life," an important amenity in the steel and concrete grid of the modern city (fig. 16).[56]

Fig. 17. Elsie de Wolfe, designer. The swimming pool at the Colony Club, 1907.

67

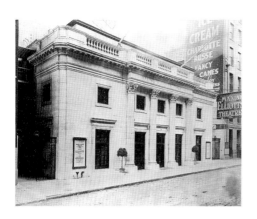

Fig. 18. Maxine Elliott's Theatre, 1908.
Photograph, Schubert Archives, New York.

But an extravagant basement-level swim-
ming pool room better suggests the the-
atrical aspect of the Colony Club as a
stage setting for some of the most influ-
ential women in Manhattan (fig. 17):

> *The ceiling of ground glass is covered
> with a lattice. Grape-vines are
> twined thickly over the lattice, their
> broad leaves and big clusters of fruit
> a most natural looking arbor.
> Electric lights are arranged above
> the glass ceiling in such a way as to
> send through it and the vines a soft
> yellow light, like sunlight filtered
> through foliage. The walls are all
> lined with mirrors which create an
> amazing effect of spaciousness. As
> one glances about the room the sin-
> gle pool is multiplied many times
> and the eye looks down a long vista
> of vine-covered, sun-lighted arbors
> and marble basins.*[57]

This is pure theater. It is no accident
that eighteenth-century French architec-
ture and decoration reappear as a sort of

modified Louis XVI style, not only in
private homes and clubs, but also in cer-
tain New York theaters of this period.
One of the most elegant, built for actress
Maxine Elliott, was patterned after the
Petite Trianon at Versailles (fig. 18).[58] De
Wolfe's friend and fellow thespian wrote
in *Woman's Home Companion*:

> *For eight years I have cherished con-
> sistently—though I am a woman—
> the dream of building a theatre that
> should be small and intimate; that
> should be beautiful and harmonious
> to the eye in every last detail; that
> should be comfortable for the specta-
> tors, and, behind the scenes, comfort-
> able and humane for every least
> player in the company.*[59]

Again the domestic and public spheres
collide as professional possibilities for
women expanded. Elliott was one of the
first women to construct and manage
her own theater in America, and she
translated her theatrical success into a
brilliant career in British society—her
villa at Cannes became known as "the
House of Lords."[60] Having arrived, how-
ever, she stopped. Once called "The
Venus de Milo with Arms," the statuesque
Maxine Elliott let herself run to fat.

But not Elsie de Wolfe, whose atten-
tion to diet, exercise and grooming never
relaxed. As she went on, de Wolfe tended
more and more to identify with the glo-
ries of late eighteenth-century France.
Throughout her life, a profusion of seem-
ingly candid photographs show her
holding beribboned lap dogs or sitting
on Watteauesque swings or conducting
fêtes champêtres. She based her costume

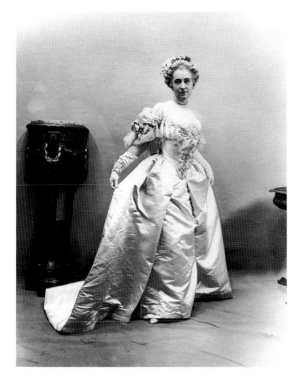

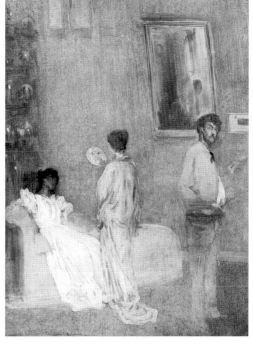

Fig. 19. De Wolfe dressed for the James Hazen Hyde Ball at Sherry's Restaurant in 1905. Photograph, Museum of the City of New York.

Fig. 20. James McNeill Whistler, *The Artist in His Studio*, 1865–66, oil on paper mounted on mahogany panel. The Art Institute of Chicago, 1912.141.

for a notoriously lavish banquet given by New Yorker Hazen Hyde on portraits of the famous dancer Mlle Camargo, a stage favorite in the days of Watteau and Lancret (fig. 19). Held on January 31, 1905, the ball—"meant to recall the splendor of Versailles"—provided an evening's fantasy for some six hundred lavishly costumed guests.[61] But de Wolfe carried fantasy further than most. Already a frequent summer visitor to the seat of the *ancien régime*, by 1902 she told her public that she would like to buy a property there.[62] By 1907, de Wolfe and Marbury were proud owners of the nearby Villa Trianon, a house that had stood vacant since the Duc de Nemours, son of King Louis Philippe, had left it in

1848.[63] Seven years later, the villa had been "rescued from oblivion and restored by the skilled hands of Miss Elsie de Wolfe to eighteenth-century perfection" and was "a meeting place for wit and wisdom of many lands," according to a two part article in *Vogue*.[64] De Wolfe was following an artistic trail blazed by Victorian painters whose carefully decorated studios were an important step in the merging of public and private spaces. In 1865, the year of de Wolfe's birth, Whistler painted his austere gray studio, relieved by bits of blue and white porcelain and animated by graceful ladies wearing the flowing gowns that de Wolfe would later affect (fig. 20). Whistler was alert to issues of packaging

—he translated certain domestic components of the carefully decorated artistic studio into powerful public exhibition display techniques that provided the setting for his performance as an artist.[65] As able as Whistler to strike a pose, de Wolfe also straddled public and private spaces as she exploited the possibilities of a self-conscious, commercialized artistic life.

Part of that life was a regular commerce in artworks old and new, located

Fig. 21. Martin Carlin, *Bed and Work Table with Trellis Marquetry*, ca. 1770–72, The Frick Collection, 14.5.67.

and vetted by artists and other freelance go-betweens who served as buyers or agents for wealthy clients dependent upon expert advice from connoisseurs of the beautiful. De Wolfe's most famous client in this vein was Henry Clay Frick, who left a French golf course "dressed in plus-fours and a plaid cap" to go shopping with her in a cluttered Paris apart-

ment in the Rue Lafitte. Not "at all disconcerted by the [untidy] junkshop atmosphere of the cluttered rooms," Frick followed de Wolfe's advice.[66] Still to be seen in Frick's museum in New York are pieces acquired at de Wolfe's recommendation, including a beautiful marquetry work table by master *ébéniste*

Fig. 22. Elsie de Wolfe, designer. Sidechair for Hope Hampton residence, New York, ca. 1939, lucite, wood, and upholstery. Barry Friedman, Ltd., New York.

Martin Carlin (fig. 21), and an airy if somewhat more theatrical forged iron console table.

"I believe in plenty of optimism and white paint," de Wolfe proclaimed. Her emphasis on lightness, first seen when she banished the dining room clutter in the house she shared with Elizabeth Marbury on 17th Street, coincided with a growing public taste for the impressionist palette in painting. However, the new in American art tends to be tem-

Fig. 23. "The Drawing-room should be Intimate in Spirit," Elsie de Wolfe's *The House in Good Taste* (New York, 1913).

pered and softened with the old. Then-contemporary impressionist landscapes are not to be found in de Wolfe's fresh new rooms—she favored eighteenth-century paintings, prints, and drawings, which she also collected for herself when in funds.[67]

When de Wolfe got around to using an innovative material, such as lucite for a sidechair, she had it cast in an old form, selecting Biedermeier, an early nineteenth-century style (fig. 22). American painters of the era exhibit similar foibles. Charles Hawthorne's picture of modern clubmen, *The Story* (ca. 1898–99, Hirschhorn Museum and Sculpture

Garden, Smithsonian Institution), is quite firmly based upon a detail borrowed from a Dutch picture he saw at the Frans Hals Museum.

Abundant photographs and paintings record de Wolfe's signature blend of English printed chintzes with simple, almost severe late eighteenth-century French furniture, or copies when antiques were too dear (fig. 23). The quality of the mix was linked to the capacity of the client's purse:

> *Without sacrificing her belief in simplicity, she made sure her wealthy clients lived in a style appropriate to their station. The simple curtains*

Fig. 24. Miss Piggy in tiara and gloves, from *Miss Piggy's Guide to Life* (New York: Muppet Press/Alfred A. Knopf, 1981, p. 36).

were silk, not muslin, the lamp-shades were hand-pleated, the wall-paper was hand-blocked and cost forty-five dollars a roll. On all of this Elsie received a commission, generally between twenty and thirty percent of the total cost of the job, which was quite enough to keep her living in the style that both she and her customers admired.[68]

That practical theatricality—the emphasis upon total visual impact rather than rigid standards of quality for individual components—made de Wolfe's look more widely accessible, and surely has contributed to the long-lasting popularity (and profitability) of her decorating style. In 1995, Sotheby's, New York, promoted "Rooms With a View":

Distinguished by its elegance, refinement, sumptuousness and attention to detail, French style is as popular today as it was in the pre-Revolutionary days

trilled the brochure copy.

The day will include a workshop on decorating in the French manner on a limited budget with furniture from Sotheby's Continental Arcade Sale. Fee $245.[69]

Like platform shoes, de Wolfe still comes and goes in American popular culture. From 1890 to 1950, no important trend seemed to escape her notice. Echoes of her continuous performance can be found in Cole Porter's "Anything Goes" and other lyrics (the thirties), in the antics of Patrick Dennis's *Auntie Mame* (the fifties), even the lavender splendors of toilette and actress-cum-career-girl affectations of the muppet "Moi, Miss Piggy" (the seventies) (fig. 24). A copy of De Wolfe's once-radical

Fig. 25. Elsie de Wolfe, 1941. Photograph, Elsie de Wolfe Foundation.

Fig. 26. Throw pillows in Elsie's home. Photograph, Elsie de Wolfe Foundation.

1912 walking suit, its skirt shortened to the ankle to permit ease of movement, is for sale in a current mail order catalogue; her 1924 photograph by Edward Steichen leads off a recent best-selling popular study of stylish women of the twentieth century.[70]

De Wolfe's magazine articles, her books, her parties centered around the interiors she occupied herself—her own spaces were experimental laboratories. "Have you ever tasted white turtle soup? Do you know what Tarhonya rice is? Have you ever eaten a duck cooked in a melon?" she asked her readers in *Recipies for Successful Dining*, 1935. "Are your plates hot, <u>hot</u>, HOT?" she demanded, presaging by sixty years the pseudo-personalization of contemporary "life-style" gurus such as Martha Stewart.[71]

In American culture, Time is Money. For a photograph dated 1941, de Wolfe wears the short white cotton gloves she established as *de rigeur* for a lady of taste and refinement going out to luncheon (fig. 25). A hole in the back let her consult her wristwatch, that practical yet fashionable timepiece, unknown until

World War I airplane pilots wore them. The former actress is slender as an ingenue, having early advocated both a careful diet and regular exercise.

De Wolfe's hats and little white gloves for afternoon wear disappeared in the 1960s, but we still exercise to keep fit; we still encounter the status wristwatch, along with blue-rinsed hair, sumptuous beige interiors filled with prestige-conferring antiques, and the occasional dramatic rise to social eminence on the wings of the "right" interior decorator. All these bear witness to Elsie de Wolfe's pliable participation in the art of social change.

One of her most endearing affectations was the scattering of elegant little pillows embroidered with truisms, sometimes poignant, sometimes funny (fig. 26). "A Life is What Our Thoughts Make It," reads one. The hat-and-gloves photograph was taken shortly after one of America's most successful tastemakers

had just fled war torn Europe amidst harrowing circumstances. Following her escape, a headline in the *Boston Post* proclaimed, "Once World's Most Famous Hostess Poor but Happy." In the interview, de Wolfe said, "A woman of the world should always be the mistress of sorrow and not its servant. She may have grief but never a grievance."[72]

Sorrows and truisms are still with us. "Money Creates Taste" contemporary artist Jenny Holzer announces in blazing lights (fig. 27). Elsie de Wolfe would probably have it the other way—"Taste Creates Money." But de Wolfe was not one to make a fuss about circumstances. "There are no pockets in a shroud," says one of the pillows. "Never complain, never explain," says another.

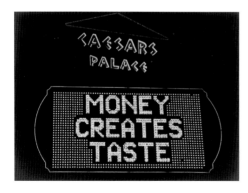

Fig. 27. Jenny Holzer, from *Truisms* and *The Survival Series*, 1986, Dectronic Starburst double-sided electronic display signboard. Installation, Caesar's Palace, Las Vegas. Courtesy, Barbara Gladstone Gallery.

1. Edith Wharton, *The Buccaneers*, completed by Marion Mainwaring (London: Viking, 1993), p. 4. Written at the time when Edward VIII was marrying Wallace Simpson, an American divorcée, Edith Wharton's unfinished manuscript was first published in 1938.

2. New York Kindergarten Association, *Fourteenth Annual Report . . . June 1903–1904* (New York: 1904), p. 8; cited H. Barbara Weinberg, Doreen Bolger, and David Park Curry, *American Impressionism and Realism: The Painting of Modern Life* (New York: Metropolitan Museum of Art, 1994), pp. 260–261. My current ideas about the significance of urban entertainments and the artist as performer were first explored in the Metropolitan project, and I am indebted to my coauthors for their generously shared insights.

3. Douglas A. Russell, *Costume History and Style* (Englewood Cliffs, N.J.: Prentice Hall, 1983), pp. 395–396.

4. The Century Company published editions of de Wolfe's book in 1913, 1914, 1915, 1916, and 1920. It was reprinted in 1975 (Arno Press), and again in 1984 and 1990 (Ayer Company). All citations below are from Elsie de Wolfe, *The House in Good Taste* (1913) (New York: Arno Press, 1975).

5. Edith Wharton and Ogden Codman, Jr., *The Decoration of Houses* (1902), with introductory notes by John Barrington Bayley and William A. Coles (New York: Scribner's Sons, 1978). Prior to publishing *Good Taste*, de Wolfe had joined forces with Codman on an East 71st Street show house where they "waved the divining rod which brought its latent graces to the surface." Wharton, on the other hand, remained for de Wolfe "sharp" with "a forbidding coldness of manner." Elsie de Wolfe, *After All* (1935) (reprinted New York: Arno Press, 1974), pp. 107, 124.

6. Wharton and Codman, *Decoration of Houses*, p. 2.

7. De Wolfe, *Good Taste*, p. 4.

8. R. and A. Garrett, *Suggestions for House Decoration in Painting, Woodwork and Furniture* (London: Macmillan and Co., 1876), p. 7, cited Peter McNeil, "Designing Women: Gender, Sexuality and the Interior Decorator, c. 1890–1940," *Art History* 17, no. 4 (December 1994), p. 633.

9. Jane S. Smith, *Elsie de Wolfe: A Life in the High Style* (New York: Atheneum, 1982), pp. 142–143. This is the definitive biography.

10. De Wolfe, *Good Taste*, p. 16.

11. Ruby Ross Wood, the ghost writer, was a journalist who eventually became one of de Wolfe's biggest competitors.

12. Smith, *A Life*, pp. 69–71, 124–125.

13. Ibid., pp. 143–144.

14. Elsie de Wolfe, "Stray Leaves from my Book of Life, a little autobiography and some fleeting thoughts by a famous woman of the American stage," *Metropolitan Magazine* 14 (1901), p. 809. In 1935 de Wolfe began her autobiography with a repetition of this tale, describing walls "papered in a Morris design of gray palm-leaves and splotches of bright red and green on a background of dull tan. Something terrible that cut like a knife came up inside [me]." *After All*, p. 2.

15. De Wolfe, *After All*, p. 102.

16. Letter, Elsie de Wolfe to Isabella Stewart Gardner, Friday, Jan. 20, 1907, from hotel Touraine, Boston. Roll 397, Frames 066–067, Archives of American Art.

17. De Wolfe, *After All*, p. 103. The Beaton painting, as well as the photograph of Elsie with an airplane, is reproduced in Nina Campbell and Caroline Seebohm, *Elsie de Wolfe: A Decorative Life* (New York: Potter Publishers, 1992), pp. 144, 147.

18. De Wolfe, "Stray Leaves," p. 809. Always candid with the popular press, she told an interviewer who asked why a society woman would go on the stage, "The great advantage is . . . that it is a pleasanter way of making a living than many others." William Armstrong, "Silhouettes: Miss Elsie de Wolfe," *Leslie's Weekly* (January 16, 1902), p. 64. At the height of her professional acting career, de Wolfe was paid $400 a week, at a time when two and a half dollars was "considerably more than the average man in New York earns per day." See Foster Coates, "Popular Amusements in New York," *Chautauquan* 24 (March 1897), p. 707.

19. Sloan, *Gist of Art*, cited in Rowland Elzea, *John Sloan's Oil Paintings: A Catalogue Raisonné*, 2 vols. (Newark, DE: University of Delaware Press, 1991), vol. I, p. 96.

20. Elsie de Wolfe, "Chateaux in Touraine," *The Cosmopolitan* X, no. 4 (February 1891), p. 397.

21. Eric Denker has located over four hundred images of Whistler, ranging from formal portraits to cigar band decorations. See Denker, *In Pursuit of the Butterfly: Portraits of James McNeill Whistler*, exhibition catalogue (Washington, D.C.: National Portrait Gallery, Smithsonian Institution, 1995).

22. John Kendrick Bangs, review of *The Way of the World*, *Harper's Weekly* 45 (November 23, 1901), p. 1180. The continuous performance—a succession of nonstop short vaudeville acts—was very hard on performers who had to "generate the magnetism to attract a large audience, year after year, in a world of entertainment that knew no season." For an analysis, see Gunther Barth, *City People: The Rise of Modern City Culture in Nineteenth-Century America* (New York: Oxford University Press, 1980), p. 208.

23. John C. Van Dyke, *The New New York: A Commentary on the Place and the People* (New York: Macmillan Co., 1909), p. 220.

24. Marianna Griswold Van Rensselaer, "People in New York," *Century* 49 (February 1895), p. 546. De Wolfe became a professional actress in September, 1890. See Smith, *A Life*, p. 41.

25. James Huneker quoted in Ira Glackens, *William Glackens and the Ashcan Group: The Emergence of Realism in American Art* (New York: Crown Publishers, 1957), p. 91.

26. Theodore Dreiser, *Sister Carrie* (1900) (reprinted, New York: Bantam, 1982), pp. 232–233.

27. Ibid., p. 409.

28. De Wolfe, "Stray Leaves," p. 910. The rocking chair publicity photograph is reproduced in Campbell and Seebohm, p. 28.

29. Malcolm Cormack, "Star Quality," *Artnews* (summer 1983), p. 112–114. I am grateful to Mr. Cormack for bringing this picture to my attention.

30. G. H. Hepworth, 1893, cited Weinberg, Bolger, and Curry, *Painting of Modern Life*, p. 258.

31. Kim Marra, "Elsie de Wolfe Circa 1901: The Dynamics of Prescriptive Feminine Performance in American Theatre and Society," *Theatre Survey* 35 (May 1994), p. 105.

32. Bangs, *Harper's Weekly* (November 23, 1901) and *New York Sun* (undated press clip), cited Marra, *Theatre Survey*, pp. 101, 110. A large collection of de Wolfe's reviews fills a scrapbook in the Billy Rose Theatre Collection, New York Public Library–Lincoln Center.

33. "Plays and Players," *The Theatre* (May 1901), p. 4. Mansfield used as an example "the case of the actor who enters the stage drawing room, puts his hat on the mantlepiece, shoots out his cuffs from his sleeves, parts his hair with his hand and engages the hostess in conversation."

34. Unidentified news clip (November 5, 1901), de Wolfe scrapbook, cited Marra, *Theatre Survey*, p. 110.

35. For illustration of "Miss de Wolfe and Miss Marbury in their Parisian automobile carriage," see de Wolfe, "Stray Leaves," p. 816.

36. Marra, *Theatre Survey*, p. 112.

37. John Sloan, diary, September 15, 1907, quoted in Elzea, *Sloan's . . . Catalogue Raisonné*, vol. I, p. 82.

38. "The Last Delmonico's," *Harper's Weekly* 28 (January 26, 1884), p. 56.

39. Dreiser, *Sister Carrie*, pp. 253–254.

40. "Miss de Wolfe's Exquisite Gowns," *Harper's Bazaar* (February 3, 1900), p. 94.

41. Unidentified press clipping, de Wolfe scrapbook, cited Marra, *Theatre Survey*, p. 107.

42. Smith discusses de Wolfe's exhibition of Shinn's work at Irving House, the Marbury-de Wolfe domicile, in *A Life*, pp. 76–77. For a social doyenne to promote sales of a young artist's work in her home was not unheard of, and provides further evidence of the merging of public and private spaces. Celia Thaxter exhibited and sold pictures by Childe Hassam and other impressionists in her parlor on Appledore Island in the 1880s and early 1890s. See David Park Curry, "In Celia Thaxter's Parlor," *Childe Hassam: An Island Garden Revisited* (New York: Denver Art Museum in Association with W. W. Norton, 1990), pp. 18–57.

43. "Lady Modish," in *Town Topics* (1899), cited in Smith, *A Life*, pp. 56–57.

44. Elizabeth Marbury, a successful theatrical agent, considered her companion's acting skills inadequate for professional survival without the protection of a powerful producer. Having "decided to become her own producer" de Wolfe "practically lost most of the money which she had saved through hard work and stringent economy." Elizabeth Marbury, *My Crystal Ball: Reminiscences* (New York: Boni and Liveright, 1923), p. 63.

45. Unidentified newspaper clipping (December 7, 1901), de Wolfe scrapbook, cited Marra, *Theatre Survey*, p. 111.

46. "After the Matinee," *Town Topics* (1887), cited Smith, *A Life*, p. 56.

47. *Mrs. Abington as "Miss Prue"*, in *Reynolds*, ed. Nicholas Penny, exhibition catalogue (London: Royal Academy of Arts, 1986), no. 78, pp. 246–247.

48. Smith, *A Life*, pp. 59–63.

49. For photographs and Oliver Messel's painting of de Wolfe as ringmaster wearing a dress by Mainbocher and controlling a group of miniature ponies, see Campbell and Seebohm, pp. 118–120.

50. Lavinia Hart, "The Way of the World Justifies Its Title," unidentified newspaper clip (November 17, 1901) in de Wolfe scrapbook, cited Marra, *Theatre Survey*, p. 110.

51. See Smith, *A Life*, pp. 102–112.

52. Anna McClure Scholl, "The Colony Club," *Munsey's Magazine* 37 (August 1907), p. 595.

53. Florence Finch Kelly, "A Club-Women's Palatial Home," *Indoors and Out* 4 (May 1907), p. 77.

54. Scholl, p. 599.

55. Ibid.

56. Illustrated Scholl, p. 595; Kelly, p. 81; De Wolfe, *House in Good Taste*, p. 270.

57. Kelly, p. 79.

58. See Nicholas van Hoogstraten, *Lost Broadway Theatres* (New York: Princeton Architectural Press, 1991), pp. 108–111. The building, erected at 109 West 39th Street by Marshall and Fox, a Chicago firm, opened on December 30, 1908. The brown and gold interior was reminiscent of Whistler's favorite interior palette for exhibitions of his work.

59. Quoted van Hoogstraten, *Lost Broadway Theatres*, p. 109.

60. *Dictionary of American Biography*, Supplement 2, to December 31, 1940 (New York: Scribner, 1958), pp. 170–171.

61. J. C. Cartwright, "James Hazen Hyde's Costume Ball," *Metropolitan Magazine* (June 1905), pp. 305–319.

62. William Armstrong, "Silhouettes," p. 64.

63. Smith, *A Life*, p. 113.

64. Ruby Ross Goodnow, "The Villa Trianon," *Vogue* (March 1, 1914), p. 45.

65. See David Park Curry, "Total Control: Whistler at an Exhibition," *Studies in the History of Art* 19 (Washington, D.C.: National Gallery of Art, 1987), pp. 67–82. These techniques not only presage contemporary performance art, but also today's museum display techniques.

66. Charles Ryskamp, "Preface," to *The Frick Collection: An Illustrated Catalogue* V (New York: Princeton University Press, 1992), p. xvi.

67. Her albums are held by the Decorative Arts Study Center, San Juan Capistrano, California.

68. Smith, *A Life*, p. 124.

69. "A Chance to Learn Something New," brochure, Sotheby's Educational Studies (winter 1995). The workshop was held on March 24, 1995.

70. J. Peterman Company, *Owner's Manual No. 36a* (summer 1995), p. 111. The worshipful text assures us that de Wolfe "gave better parties than Elsa Maxwell. Taught Wallis Simpson which fork to use. But nobody called Elsie de Wolfe a social butterfly. Not when she could sell Mr. Frick $3 million worth of antiques (at 10% commission) in half an hour. Or win the Croix de Guerre during WWI." For the Steichen photograph, see Annette Tapert and Diana Edkins, *The Power of Style: The Women Who Defined the Art of Living Well* (New York: Crown, 1994).

71. Elsie de Wolfe (Lady Mendl), *Elsie de Wolfe's Recipies for Successful Dining* (New York and London: Appleton-Century Company, 1935), pp. 13, 17. "It does not matter whether one paints a picture, writes a poem, or carves a statue, simplicity is the mark of a master-hand," she advised. Sixty years later, Martha Stewart commented on "a simple setup" for a Christmas party, sighing "I have often wished that I could learn from such lessons in simplicity." See "A Letter from Martha," *Martha Stewart Living* (December 1995–January 1996), p. 8.

72. George Brinton Beale, *Boston Post* (May 2, 1942).

Private Museums, Public Leadership: Isabella Stewart Gardner and the Art of Cultural Authority

Anne Higonnet
Wellesley College

Isabella Stewart Gardner made herself a cultural leader by exercising the authority of a museum. This was a project that far exceeded her role as a collector, which is to say that a museum can act as very much more than the sum of its parts. Or rather, a museum, the Gardner Museum for instance, only begins to act, to function, to exercise authority, once it becomes something else besides a collection of art objects. Gardner's genius lay in her understanding that she could be the individual who controlled and designed that authority. In order to do so, she had to understand how to exert authority in specifically visual forms that went beyond the art objects she had acquired.

My first task is to address a seeming paradox. How can a private museum exercise public leadership? To answer this question, let me put the Gardner Museum in its historical institutional context.

The Gardner is one among dozens of private museums, some of them as important as the Wallace Collection, the Musée Condé, the Frick Collection,

the Huntington Art Collections, and Dumbarton Oaks. The great examples of this museum type were founded between 1890 and 1940, based on collections begun around 1848. These private art museums expressed many of their century's most fundamental concepts about art's value, about art's role in history and in contemporary culture, about where art should belong, and to whom.

The type of the private museum is closely related to other museum types, but remains distinct. Think of the difference between the above mentioned private museums and the type of the house-museum, of which Mt. Vernon is an outstanding example. Or think of the difference between private museums and a museum based on an artist's studio, the Musée Rodin for example. And of course there's the obvious contrast with the metropolitan or national type, the Gardner's neighbor the Boston Museum of Fine Arts, for instance. To define the type chronologically, compare the Gardner with the very early nineteenth-century Soane museum in London, which was

not devoted primarily to the exhibition of an art collection for the purpose of public viewing pleasure, but rather for professional instruction. Nor is the Gardner quite like the privately founded museums that came after it. Consider, for instance, the contrast between the very personal esthetic of the Gardner and the much more detached esthetic of the DeMesnil collection in Texas, which looks like a small public museum. The private museum begins with an art collection which a private founder shapes into the skeleton of an apparently domestic installation intended to become a public museum.

The modern art museum, as a broader type, works to produce a collective sphere for art defined as public, and in the case of museums devoted to what we call great or high art, to determine the dominant register of visual culture. A private art museum like the Gardner accomplishes tasks within that work: connecting history and individuality; distinguishing between public and private; situating femininity in relation to public and private values; and redefining artistic quality.

The private museum was in a position to affect the culture of the late nineteenth, early twentieth century, and, more importantly, to affect how culture would register and shape social and political values. In other words, to exert authority. Cultural leadership consists in an influential and innovative—in America we like the word pioneering—cultural authority. My tasks now become, then, first: to establish that the

Gardner Museum, both separately and as a part of an institutional type, exerted cultural authority, and second: to establish that its authority was influential and innovative.

The Gardner seems to be all about a European past. Which is precisely why, paradoxically, it manifests a patriotic authority, one which asserts America's national superiority. During the age of the private art museum, Europe had to construct a republican culture on royalist foundations. Meanwhile America had to come to terms with its belief in Europe's cultural superiority and assert a role in world culture commensurate with its new political and economic power. One way, the modernist way, was to react against Europe and against the past. But another way was to claim a European past as one's own, as something America could own.

American private art museum founders took European models in order to give America what they believed America lacked, but also deserved. At the age of sixteen, Isabella Stewart announced that someday she would have a home like the Museo Poldi-Pezzoli in Milan, "filled with beautiful pictures and objects of art, for people to come and enjoy."[1] Americans wanted to share a European past. But since they could not simply find it around them, they had to import it. After seeing the Wallace Collection, Henry Clay Frick confided to a friend: "The American people are fond—and properly so— of going to Europe, chiefly to see the famous paintings and other works of

Fig. 1. The Dutch Room, looking toward the second-floor stairhall. Between the doorway and the court window are Rembrandt's 1629 *Self-Portrait* (left) and a portrait by Dürer. All photographs in this essay are by David Bohl, 1993, and reproduced courtesy of the Isabella Stewart Gardner Museum.

art there. I am going to try to bring some of them here where all Americans may have the opportunity of seeing them without crossing the ocean."[2]

For many members of America's intellectual elite, immersion in a recreated European past was their way to find a secure personal and national identity.[3] Bernard Berenson said that the "four most authentic Americans in his generation were Edith Wharton, Henry James, Henry Adams, and himself."[4] Berenson, James, and Adams were all close friends and admirers of Gardner's, while Wharton's writings provide the literary analogue to Gardner's visual sensibility. Along with such prestigious peers, Gardner believed that America's place in the present could only emerge out of the past. American authority had to be found in a relationship to the past, and it was a function

of the museum to help create that relationship.

A museum like the Gardner not only creates a narrative of history, but makes its viewers a part of that narrative. Private museums, which tended to be founded a generation or two after their local, national, or municipal counterparts, reacted against their institutional predecessors by emphasizing the organic visual coherence of historic periods and the empathetic possibilities that organicism offered to visitors. For private art museums specialized in making people feel at home with history by providing what was always described as "living" displays as opposed to the "dead" spaces of the national or municipal museum.[5]

Gardner made her museum a historical narrative, a spatial narrative. In the Museum you can move through 2,000

years in as little as a half an hour. From the central courtyard with its classical sculpture and mosaic up to the medieval chapel into the quatrocento Italian room through the sixteenth-century "Titian Room" into the seventeenth-century "Dutch Room" (fig. 1) on past the eighteenth-century "Little Salon" with a possible exotic detour down a Spanish hallway. This is a version of European history that today we can see summarily as prefigurations of capitalism grounded in European antiquity.

This juxtaposition of neighboring spaces, each filled with objects that as a group represent one time and place —seventeenth-century Holland, for instance—is what distinguishes a museum like the Gardner from previous museums. There had of course been collections of art installed in private dwellings at least since the Renaissance, but these installations did not cite the past as organic entities, nor did they string together such groups of objects into historical narratives.

But where, you will ask, are the Gardner's nineteenth-century rooms? Superficially, down on the ground floor by the entrance. More powerfully, however, the Gardner signifies the present with its display of the past, with its belief in itself as the culmination of history. Every room signals the cultural and economic power of America at the turn of the century, the power that enabled Gardner to purchase and display the cultural treasures of every past, and foreign, culture.

The visitor who is thus impressed with America's cultural authority is very much an individual visitor. For the Gardner Museum manages to assert at once collective and personal power. Everything about the museum celebrates both history and individualism. And this individualism of the Gardner in turn represents at once a general idea and a particular person.

The very term private art museum unites the concept of privacy with the public functions of a museum. Private art museums were understood in their time to achieve a precarious and precious balance between private and public political values, between the individualism and civic responsibility both considered vital to a democratic ideal. Museum founders like Gardner believed that by purchasing some of the most famous of all art objects and orchestrating sumptuous displays, they could ennoble both themselves and their nation while fostering democracy, by exhibiting at once personal power and civic service, individual taste and a collective cultural heritage. Henry James called the activity of museum founders "acquisition on the highest terms."

All private museum founders described themselves at some point as a steward. They were convinced that they acted as merely the temporary guardians of objects that belonged to the public. They would never have assembled such great collections if their beliefs had not been genuine. Advisors and dealers always in the last resort appealed to collectors as museum founders. Berenson wrote to Gardner when Titian's 1562 *Europa*, which she had just bought,

arrived in Boston: "I also spend much time dreaming of your Museum. If my dreams make but a fair approach to realization yours shall not be the least among the kingdoms of earth."[6]

At once self-aggrandizing and selfless, the private art museum accomplished a capitalist goal. Capitalism assumes that if all members of society try to become as rich as possible, society as a whole will automatically benefit. Private museums provided a flagrantly visible proof of this felicitous calculation. In the meantime the private museum was supposed to compensate for an unequal distribution of wealth. The fortunes made by families like the Stewarts and the Gardners were acceptable if returned at least partially in philanthropic form. A museum, moreover, returned more than money; it paid cultural interest, as it were. Private museums were perceived as components of a cultural heritage. It may seem strange to us today that a heritage so opulent and elitist could be considered common, but it was. A century ago western democratic ideals posited the moral elevation of all citizens to a shared canon of values. Within the space of the private museum, those ideals could be imaginatively fulfilled. Every visitor becomes for a brief moment the founder of the museum, the mistress or master of the house. Whether this was a ludicrous fantasy or a constructive dream remains open to debate.

On the walls of the Gardner hang two plaques: one announces that Fenway Court is indeed a museum; the other is adorned with a phoenix rising from the ashes to immortality and emblazoned with Gardner's motto: "C'est Mon Plaisir" (which translates as either "it is my will" or "it is my pleasure" with an ambiguity that suited Gardner). Taken as a pair, and they look like a pair, the two plaques summarize the relationship Gardner's museum creates among art objects, her individuality, and her cultural ambition. Gardner made self and art object, identity and the collection, society and the museum symbolize each other. The quality ascribed to the art object called beauty promises the power with which a self can at once court and shield itself from the gaze of others, which allows the self/art object to be permanently exposed and preserved.

Gardner identified personally with many objects in her collection. To help convince her to buy Titian's *Europa*, for instance, Bernard Berenson pleaded: "it would be poetic justice that a picture once intended for a Stewart should at last rest in the hands of a Stewart."[7] No object, however, was more obviously, or more powerfully, invested with her personality than her portrait by John Singer Sargent (see p. 56; fig. 4).[8] Long after we have forgotten the many convoluted reasons why Gardner believed art objects were destined for her by fate, we still feel vividly how Gardner has inscribed her identity into her museum with this painting.

Sargent painted the portrait in late 1887 and early 1888. Gardner chose to wear a closely fitting black dress that exposed the throat and arms for which she was famous. Gardner liked publicity about her physical charms; she kept

newspaper clippings reporting: "She has a superb neck and arms," or "Has the handsomest neck, shoulders and arms in all Boston." When the portrait was first exhibited in Boston soon after its completion, critical reaction to her feminine beauty followed, partly, in the same tone: "the ideally beautiful arms and hands are modelled in the most exquisite fashion." The portrait, however, pictured something rather different than a traditionally feminine sexual object. Both Sargent and Gardner claimed responsibility for the Renaissance textile that commentators all saw as an aureole around Gardner's head. The religious connotations of the halo as well as of a hieratic pose, however, were modified by the effect of Gardner's jewels, worn surprisingly around her waist and on her slippers. Adorned with precious pearls and rubies, this was no figure of religious ascetic abnegation, but rather of commanding authority. Gardner, both adorers and detractors concluded, had cast herself as an idol: "The American Idol," wrote the novelist and critic Paul Bourget (himself French).[9]

Before the exhibition had closed, Jack Gardner, Isabella's husband, had withdrawn this image from public display, and said it would never again be publicly seen as long as he lived.[10] A friend remembered him saying: "It looks like hell, but it looks just like you."[11] Rumors had circulated at the time about a liaison between Isabella and Frank Marion Crawford. Playing on the name of a fashionable White Mountains resort, Bostonians joked that "Sargent had painted Mrs. Gardner all the way down to Crawford's Notch." These stories have been repeated by Gardner's biographer Louise Hall Tharp.[12] In a 1951 book titled *The Lady and the Painter* and described as an "extravaganza based on incidents in the lives of the two principal characters," the author Eleanor Palffy takes the Sargent portrait as the origin, and visual proof, of Gardner's sexual passion for Sargent.[13] It doesn't matter whether these stories are factually true. They articulate a lingering perception, itself a kind of truth, that the portrait expresses Gardner's modern freedom, a freedom which was in its time considered illicit.

In her own lifetime, Gardner herself seemed to want to keep this freedom a secret. Although she always maintained that the portrait was Sargent's best work, she would not loan it for exhibition, despite Sargent's repeated and friendly requests. As she prepared her museum, one room remained almost always closed. After she died in 1924, it was revealed. The Gothic Room was organized around Sargent's portrait. Gardner had reified all the 1888 critics' metaphors. Hung in a corner of the room where Russian holy icons are placed, surrounded by stained glass, statuary, wood carvings, and with a long, altar-like table in front of it, Gardner had canonized herself as the patron saint of the museum. Isabella had not disobeyed Jack—directly. The Sargent portrait was still at home—in a sense (fig. 2). Isabella had merely proceeded, as Henry James described her museum project in 1907, "to displace a little the line that separates private from public property."

Fig. 2. The Gothic Room, looking toward John Singer Sargent's 1888 portrait of Gardner.

Fig. 3. The Courtyard with the second-century Roman mosaic depicting Medusa.

We are, of course, all the more struck by Gardner's assertion of her individuality because she was a woman. Indeed, of all Gardner's assertions of authority, her assertion that a woman could wield authority was the most pioneering. Here I cannot resist repeating a point that Carolyn Heilbrun made in a devastatingly funny talk she gave at the Gardner Museum. Heilbrun observed that the collection contains a remarkable number of images of strong women besides herself, such as the dancer in Sargent's *El Jaleo*, and even rather frightening women, such as Medusa at the very heart of the museum, in the center of the courtyard mosaic (fig. 3).

Gardner was not, however, alone among museum founders. One of the easiest ways to dispel the label "eccentric" which has all too often been attached to Gardner is to recognize how many women founded private museums. Indeed, fully half of all private museums were founded or co-founded by women, women like Wilhelmina Van Hallwyll in Sweden, Arabella Huntington, the force behind the scenes of the Huntington Collection, or Mildred Bliss, the real founder of Dumbarton Oaks.

Because they seemed to be both homes and institutions, private art museums allowed women to move from private toward public roles without opposition. Denied many other forms of self-expression and social power, women gave shape to their desires through the transformation of feminine homes into public institutions. In Sweden, Van Hallwyll decreed in her will that the Hallwyllska Museet director would always be a woman—and one with a Ph.D. In America, Gardner pointedly named her museum after herself alone: the Isabella Stewart Gardner Museum.

Gardner is probably the most famous of all private museum personalities, male or female. Her own Bostonian contemporaries delighted in spreading stories of her pranks. Boston newspapers regularly commented on her charms and her pranks, and one reporter, almost always cited in any story about Gardner, went so far as to claim that "All Boston is divided into two parts, of which one follows science, and the other Mrs. Jack Gardner."[14] Rather than just enjoy the outrageous verve of her behavior, however, I take the ways Gardner made a spectacle of herself as only the most obviously feminine end of an exhibitionist spectrum, at the other end of which was her museum. All the women who founded private museums, I would argue, fashioned similar spectra for themselves that stretched from the gendered roles their social circumstances assigned them all the way to the pioneering public roles museums allowed them to play.

So much for the effects of Gardner's cultural authority. What about her means? I have only referred to them implicitly. So let me now be explicit. As I see it, Gardner used two kinds of specifically visual means: one which involved individual art objects, and another which involved groups of art objects installed in spaces.

Gardner's collection occupied a crucial position in the history of collecting.

She acquired art objects for reasons and in ways that initiated the values of art we call modern, and which we still accept today. This change in values involved the joint interests of collectors, dealers, and art historians, who together constituted our modern artistic values. Gardner's relationship with Berenson provides a paradigmatic case study.

Unlike previous collectors, Americans in the late nineteenth and early twentieth centuries bought on what we would call an open, public market. With their tremendous assets in stocks and bonds rather than in land, they intentionally exploited financial liquidity to draw art objects out of churches, family estates, and other traditional contexts (which we might call private) (fig. 4). Most fundamentally, American collectors attached a money value to art objects of all sorts. The great turn-of-the-century sociologist Georg Simmel explained "the philosophy of money" by "an analogy with aesthetic value," a value "in the absence of any utility" he traced to Immanuel Kant's philosophy of art.[15]

Much more money value was attached to some objects than to others. Of course some objects had always been hailed above others. But American collectors, including Gardner, valued paintings comparatively more than paintings ever had been before, and moreover they fanned out the values ascribed to different paintings.[16] In this they collaborated —and I use the word collaborate insistently—with art historians and later with dealers. Gardner and Berenson needed each other, and they worked together

well because they egged each other on in a shared direction that was mutually beneficial.

It has too often been said that Gardner needed Berenson, or even that he is the genius behind the museum. But let us think for a minute about the ways in which Berenson needed Gardner. In a simple sense, Berenson made his fortune by charging collectors commissions that seem to have hovered around 10–15%

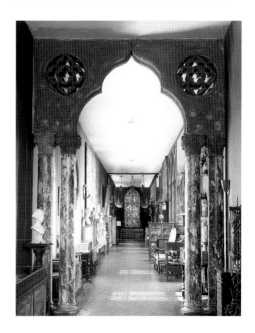

Fig. 4. The Long Gallery, looking down the object-filled corridor toward the chapel with an early thirteenth-century stained-glass window from Soissons Cathedral.

plus expenses per sale. Collecting for Gardner, moreover, gave Berenson the cachet that facilitated transactions with other collectors. More fundamentally, someone like Gardner, motivated by the idea of a museum, promoted the

financial value that matched and guaranteed the kind of esthetic value Berenson was promoting. Art historians, led by Berenson, effected a triage between paintings and all other kinds of art, and then among paintings themselves, placing artists in a hierarchy and pronouncing on quality; Berenson made his reputation by ascribing objects to authors, by sorting out the authentic from the fake, the inspired from the ordinary. But this would all have been academic, literally, without the money value that collectors provided, the money value that is an intrinsic part of our modern concept of the masterpiece. The objects in Gardner's museum were invested with the mutually dependent authorities of knowledge and price.

Once launched on this dialectically driven trajectory, artistic value could only escalate. Consider the case of Gainsborough's 1770 *Blue Boy*. Gardner collected early enough that she could obtain paintings at what in retrospect seem like comparatively low prices. She was unable to get the *Blue Boy* through Berenson in 1896 for £30,000 — a price that made her exclaim rather gleefully: "I shall have to Starve [sic] and go naked for the rest of my life."[17] But she did manage at the same time to buy Titian's 1562 *Europa* for £20,000. In 1921, Henry and Arabella Huntington had to pay more than five times as much for the *Blue Boy* as Gardner had contemplated: $728,000. Twenty-five years later, the market had evolved. Duveen and professional dealers like him had done their work. Unlike Gardner, the Huntingtons

did buy through dealers, almost always Joseph Duveen, sometimes called the world's greatest salesman. Duveen relied heavily on the expertise of art historians, notably Berenson's, but Duveen brokered that authority, as well as inside tips about availability provided by a network of paid informants. Duveen also believed in a large profit margin for himself.

Gardner helped lead our modern reevaluation of the artistic masterpiece, but she also did more. She made artistic values function within a broader social and political world. It is the Gardner Museum as a whole that makes the objects in its collection function ideologically. All of the effects of Gardner's authority I've spoken about, nationalist, individualist, and feminist, all were accomplished only very partially by discrete objects. Those effects could only be fully accomplished by the ways in which Gardner compounded their meanings into what I call refracted images.

Meanings accrue to objects after their making and as they function, emphatically and visually so in an art museum. Though a number of art historians have been suggesting that our traditional notions of the image, or object, have been too limited,[18] and though many art historians have demonstrated how the meanings of objects or images can be altered by their original spatial context,[19] art history has yet to explain how images become the components of subsequent visual contexts that modify original meanings, or how, in other words, an image mutates into another image. (Which is quite distinct from the propo-

sition that one image will be perceived differently by different audiences at different moments in history.) Here I propose to enlarge our concept of the image from what I call "produced images" to include what I call "refracted images."

Gardner organized all the items in her collections with a purpose, consciously or unconsciously expressing her values through art objects. Gardner's spatial historical narrative, for instance,

the museum. Already, by placing her Renaissance textile and her jewels within her Sargent portrait, Gardner was refracting their meaning. The finished portrait accumulated plenty of meanings at its first 1888 exhibition. But the portrait's most powerful and subversive meanings were created by Gardner's refraction of the portrait with her Gothic Room.

Gardner knew how to amplify an object's visual possibilities through

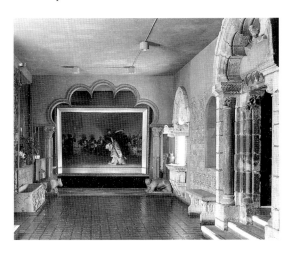

Fig. 5. The Spanish Cloister, looking toward *El Jaleo*, 1882, oil on canvas, by John Singer Sargent.

Fig. 6. The Titian Room, looking toward Titian's *Europa*.

depends on refraction. Objects only signify a period by being juxtaposed with each other and embedded in rooms. And period rooms, in turn, only signify the past by being spatially joined within and as the Museum.

El Jaleo's female figure achieves its strength because it resonates with other female figures in the museum (fig. 5). The mosaic Medusa's significance would be diminished if Gardner had not made her literally the central point of

installation. As she did, she wove her own authority into the authority with which art history had already endowed her collection. Rather than think of Gardner as someone who collected paintings and other things besides, we should think of Gardner as a collector whose diverse acquisitions obeyed the logic of her own creative project, a project constituted by the entire museum installation. The furniture, textiles, ceramics, stained glass, autograph

letters, plaster casts of famous people's hands, and architectural fragments function as integral parts of visual meanings Gardner herself created.

Some of Gardner's refracted images are easier to accept than others. Everyone seems to love the central courtyard, which frames paintings with architectural fragments, themselves framed by painted walls, plants, and classical sculpture fragments, all set on the visual pedestal of the Medusa mosaic. Less conventional are installations like Gardner's juxtaposition of Titian's *Europa* with a piece of silk that had once been part of a skirt of hers, and the placement of both objects in the angle of a room. The artistic hierarchies we have been raised with have been upset: masterpiece paintings are not, conventionally, compared with skirts and relegated to corners (fig. 6).

Gardner so often flouted such artistic hierarchies, and so often with the signs of a particularizing femininity and domesticity, that she seemed to be pitting the authority she fashioned for herself against the universalizing, hierarchical, and masculine authority of art history (fig. 7). Perhaps that was exactly her intention, if only sub-consciously. (We also need to remember, however, that Gardner worked at a time in which the authority of masterpiece paintings was still in formation, which is one reason why Gardner could feel able to work so freely.) Gardner's protection of her installations with her notorious will could be attributed simply to egomania. Her insistence that nothing on display in the Museum be permanently moved

could also be attributed to her sense of a discrepancy between her own authority and the authority of the professional art world to which, despite any such discrepancy, she wished her creation to belong.

We shouldn't need such a will to preserve the Gardner's installations. I would argue that refracted visual meanings are the ones that make museums active elements of visual culture, rather than

Fig. 7. The Little Salon.

merely inert repositories. This is why it is so important that original museum spaces like the Gardner's be preserved. These are the spaces through which, at the time they were made, art objects were made to function visually, and those visual functions are crucial parts of any history of visual culture. We will always have difficulty understanding the role art objects played in the nineteenth and twentieth centuries unless we can understand how they functioned as parts of museums. Spaces like the Gardner's are

themselves historical documents of the highest order. They are one of the most important links, or rather, interfaces, between the meanings lodged within art objects and broad historical issues. When we learn to see and study refracted meanings like the Gardner's, the history of art will become an integral component of cultural history, and, conversely, visuality will appear to be a pervasive and powerful aspect of history.

And, not incidentally, we may be able to reassess the contribution to cultural history of someone like Isabella Stewart Gardner. Art objects in our modern society have visual authority. It is those who make art objects function who exercise cultural leadership. Isabella Stewart Gardner's art collection gave her authority. The museum she designed made her a cultural leader.

1. Morris Carter, *Isabella Stewart Gardner and Fenway Court* 3rd ed. (Boston: Trustees of the Isabella Stewart Gardner Museum, 1972), p. 15.

2. George Harvey, *Henry Clay Frick The Man* 2nd ed. (privately printed, 1936), p. 336.

3. T. J. Jackson Lears deals with this issue tangentially in his *No Place of Grace: Antimodernism and the Transformation of American Culture 1880–1920* (Chicago & London: University of Chicago Press, 1981).

4. As paraphrased in R. W. B. Lewis, *Edith Wharton: A Biography* 2nd ed (New York: Harper and Row, 1985), p. 406.

5. Warren Leon's and Roy Rosenswig's collection *History Museums in the United States* (Urbana: University of Illinois Press, 1989) shows how this kind of representation of history was carried out in history museums of the same period.

6. Rollin van N. Hadley, ed., *The Letters of Bernard Berenson and Isabella Stewart Gardner 1887–1924* (Boston: Northeastern University Press, 1987), p. 56.

7. Hadley, pp. 53–56.

8. Kathleen Weil-Garris Brandt has written the key essay on this portrait and Gardner's identity, "Mrs. Gardner's Renaissance." It was first published in the 1990–91 issue of *Fenway Court* (Boston: Trustees of the Isabella Stewart Gardner Museum, 1992), pp. 10–30.

9. Paul Bourget, *Outre Mer: Impressions of America* (New York: Charles Scribner's Sons, 1895), pp. 106–109. Also excerpted in Brandt, pp. 26–28.

10. See Louise Hall Tharp, *Mrs. Jack: A Biography of Isabella Stewart Gardner* (Boston: Little Brown & Co., 1965), p. 134; and Carter, pp. 104–105.

11. Quoted by the painter Theodore Robinson in his diary, June 24, 1892 (New York: Frick Art Reference Library).

12. Tharp, pp. 131–135.

13. Eleanor Palffy, *The Lady and the Painter* (New York: Coward-McCann, 1951).

14. Hilliard T. Goldfarb, *Isabella Stewart Gardner: The Woman and the Myth* exhibition catalogue (Boston: Trustees of the Isabella Stewart Gardner Museum, 1994), p. 11.

15. Georg Simmel, *The Philosophy of Money* (pub. 1907), trans. 1978, David Frisby, ed. (London and New York: Routledge, 1990), pp. 73–75.

16. Lawrence W. Levine's *Highbrow/Lowbrow: The Emergence of Cultural Hierarchy in America* (Cambridge: Harvard University Press, 1988) provides a nineteenth-century historical context that ranges across all the arts but concentrates on drama and music.

17. Hadley, p. 54.

18. For instance Donald Preziosi, "The Question of Art History," *Critical Inquiry* 18, no. 2 (winter 1992), pp. 363–386.

19. A recent chapter by Marcia Pointon, for instance, "Spaces of Portrayal," in *Hanging the Head: Portraiture and Social Formation in Eighteenth-Century England* (New Haven: Published for the Paul Mellon Centre for Studies in British Art by Yale University Press, 1993) compellingly suggests how individual portraits signify in the context of the frames and rooms in which they were intended to hang.

The Special Connection: Albert Barnes and Lincoln University

David Levering Lewis
Rutgers University

Acting president A. O. Grubb of Lincoln University, the second oldest African American collegiate institution, boasting Langston Hughes and Thurgood Marshall among its distinguished graduates, was at a loss as to how to reply to William Schack's urgent letter of December 16, 1959. *Art and Argyrol*, Schack's unauthorized biography of Albert Barnes, was almost ready to be sent to the publisher. Schack had just heard that, a short time before his death, Barnes removed Lincoln from the amended indenture creating the foundation bearing his name. Had Lincoln University retained the power to appoint successors to the original trustees of the Barnes Foundation, Schack wanted to know? Expressing regrets in late January, Dr. Grubb wrote the biographer that it was not "desirable at this time to go into the Barnes Foundation matter any further." He feared that it might very likely "upset" the officers of the Foundation were he even to place a telephone call to one of the attorneys representing that impenetrable institution. The perplexed acting president

shared with Schack the astonishing reflection that, "if there were anything in the possibility of Lincoln's election of a Barnes trustee," his own trustees would have "leaped at the opportunity."

Fortunately for Lincoln, Dr. Grubb's highly plausible assumption was premature. But after the controversial departure in 1957 of Horace Mann Bond, Lincoln's first African American president, there was now no one in the administration who remembered the details of the Barnes-Lincoln arrangement or who could suggest a ready way to recover them. With the passage of each year, the school's administrators had found it increasingly difficult to communicate with the officers of the Foundation, who were notoriously jealous of their privacy. To some degree, the University's dilemma was partly self-inflicted: angered by the unceremonious haste of his termination after twelve years of service, President Bond had left the campus with most of the official correspondence generated during his tenure in office. Lincoln's administrators had good reason to fear that the contentious

Barnes had changed his mind about the worthiness of a small, rather isolated, historically black, liberal arts men's college of modest resources to preside over the destiny of one of the world's finest art collections. Before his departure, even President Bond had become prey to doubt, confiding to a trustee that there was only a "thousand to one chance, or even greater," that the indenture had remained unchanged.

It is only now, based on full access to the archives housed at the Barnes mansion outside Philadelphia and to the presidential papers at Lincoln, that the full story can be told of the evolving relationship between the school and the museum. Although the history of the Barnes Foundation's relations with other institutions was one of courtships aborted and reputations besmirched, leaving much of the Pennsylvania artistic and academic establishment smoulderingly hostile over the years, the remarkable truth was that the terms of the relationship with Lincoln remained what they had been when Horace Bond had read them for the first time in Albert Barnes's library on March 1, 1951. "When I get in proper shape, I want you to come here and read what I have planned for Lincoln in the distant future," Barnes had written Bond at the beginning of the year. But with characteristic cageyness, Barnes had seen his guest off without giving him a copy of the extraordinary document. "As I remember it," Bond informed Lincoln's attorney, after an anxious interval without news from the Foundation, "this is what it said:"

The Trustees of Lincoln University shall elect the successors to the Trustees of the Barnes Foundation: provided, that no member of the Board of Trustees, or of the Faculty, or of the Staff, or any of the following institutions may be so elected: The University of Pennsylvania, Temple University, Bryn Mawr College, Haverford College, or Swarthmore College.

Five months later, the pharmaceutical tycoon died in an automobile crash. Seventeen years were to pass before Lincoln would appoint its first trustee to the Barnes Foundation.

Albert Coombs Barnes built his empire on a chemical potion deemed to be so effective in combatting infections that, in a few short years, it achieved in the eyes of much of the world's medical profession a potency akin to holy water. Argyrol, the secret antiseptic source of his enormous wealth, was developed by Hermann Hille, a brilliant German chemist with a doctorate from Heidelberg. Hille and Barnes soon became sole owners and equal partners in a hugely successful Philadelphia pharmaceutical company, located at 24 North 40th Street. Revenues from the sale of Argyrol, their unpatented silver nitrate compound, and Ovoferrin, an iron tonic, rolled in after 1902 in such waves that by 1907 net profits reached $186,188.53. Dripped into the eyes of millions of newborn Americans and liberally applied to sore throats and running noses of children and adults, Argyrol was the elixir of the early twentieth century. "Our silver com-

pound should be valuable in the treatment of genito-urinary diseases," the company literature boasted, although widely accepted claims that it cured venereal disease were certainly dubious.

Barnes was equally successful in approaching members of state legislatures, with the felicitous result that more than a few enacted laws requiring hospitals to administer Argyrol to newborns. As sales continued to soar, however, the partner's relationship soured, and in 1907 Barnes and Hille Manufacturing Chemists of Philadelphia, London, and Sydney was dissolved. Hermann Hille surrendered the Argyrol formula, took his share of the profits, and went to Chicago to start over. Barnes reorganized the firm as A. C. Barnes Company. In 1922, he announced his intention to create an arts foundation, and within two years he would move his art treasures out of Lauraston, the rather nondescript homestead named after his wife, Laura Leggett Barnes, into a stately structure commanding twelve acres of prime Main Line grounds and gardens.

Looking back, it is clear that his reputation as "the terrible-tempered Dr. Barnes" emerged slowly, rather than, as it seemed to many Philadelphians, almost overnight. But none could mistake the reality that the Barnes Foundation was other than the objectification of Barnes's personality, which was alternately generous and suspicious, intelligent and prejudiced. During the early years of the Foundation's existence, its master did a fair job of constraining his demons. Ten years later, however, cold war had been declared on

the Main Line and with the national art establishment. The Foundation's increasingly aloof attitude fostered widespread skepticism about prospects for collaboration on the part of other artistic and academic institutions. The growing list of disappointed museums, colleges, and universities approached by the mercurial tycoon with the publicly announced intention of an eventual donation of his art collection after a trial period of association ultimately ran from the Philadelphia Academy to the University of Pennsylvania to Haverford, Swarthmore, and Wellesley.

It was hardly surprising, therefore, that the Philadelphia establishment responded with an incredulity degenerating into bigoted derision when rumors about Lincoln's special relationship emerged in the early 1950s. Not even the cantankerous Barnes could have been so perverse as to deed a multimillion-dollar art museum to a small black college in the Pennsylvania backwater, it was said. A good number of Main Line dwellers would have guffawed had they read William Schack's letter to the dismissed Horace Bond concerning an improbable connection: "Dr. Barnes's relationship to Negroes as individuals and as a group is a fascinating and so far unresolved subject to me." Yet, however improbable in an era of legal segregation in the South and blatant discrimination in the North, "Dr. Barnes's relationship to Negroes" was a deeply emotional one that had a longstanding history.

His interest in African Americans began "when I was eight years old," Barnes

was fond of recalling. Taken by his parents to a camp-meeting in Mechanicsville, New Jersey, he was so swept away by the unbridled intensity of the experience that, as he would often declare, "it has influenced my whole life." Barnes's affection for and fascination with the Negro race were invoked too often and too vividly not to have been authentic, and he would elaborate over the years a comprehensive philosophy of artistic production based on the special energies and gifts of peoples of African descent. Emotional affinity was intellectually reinforced by Barnes's readings in Freudian and Jamesian psychology and in the educational and philosophical writings of John Dewey. Freud's expatiations on the irrational and unconscious were clearly relevant, but Barnes embraced James and Dewey as preeminent mentors. Both deemphasized abstract principles and stressed growth through experiment. Barnes doted on Dewey's great work *Democracy and Education* (1916), warmly embracing its premise that moral and psychic evolution depended upon ever-broader sharing of experience and a deep understanding of humankind's roots in nature. Even as Barnes's celebration of what he had always perceived as the Negro's special gifts of naturalness now had formidable backing, he was discovering even more compelling justifications in the radical new writings of the Englishmen Clive Bell and Roger Fry, as well as in extraordinary African masks and sculpture assembled by his new Paris advisor, agent, and friend, Paul Guillaume.

"Please remember," he told Guillaume in late 1922, "[that] I intend to try to have the best private collection of Negro sculpture in the world."

One warm afternoon in 1923—unforgettable for Barnes—he chanced upon Roger Fry in animated discussion about African art with Guillaume at the latter's gallery. For Barnes, Guillaume's crammed emporium in the Rue de la Boetie had acquired the aura of a holy place, a shrine of wisdom and commerce he would soon christen "The Temple." That afternoon in The Temple he experienced an epiphany. "I listened for a while," the collector recalled, "and then took possession of Roger Fry and had a talk on Renoir and Cézanne, which I shall remember for the rest of my life." The collector came back to Merion in an exhilarated frame of mind—determined yet again upon another attempt at transforming the arts in America. If Barnes had "gone primitive," to borrow the evocative title of Marianna Torgovnik's splendid book, its manifestations were to be distinctly more democratic than either Fry's or Guillaume's. Bell, Fry, and Guillaume extolled African energies, but had met few, if any, native Africans. The African Americans Barnes set about cultivating had probably seen even fewer Africans than the European aestheticians, but this was merely a detail to a businessman who had turned a silver compound into a universal cure.

It was his good fortune that at that very moment a small group of well-educated and strategically positioned men and women of color was poised to

launch its own arts-and-letters movement. One or more he must already have met: the issue of *Opportunity* for May 1924 was virtually devoted to Barnes. It carried Locke's "Dr. Barnes," a lively profile of the connoisseur and the highly unusual workforce at his Argyrol plant. "He was the first and is distinctly the last word in Primitive African Art," the Howard philosophy professor underscored. Barnes contributed "The Temple," his reverent description of "high priest" Guillaume and his gallery, to which come all those who have "made the art history of our epoch." In "A Note on African Art," Locke delved brilliantly into African sources of the European artistic and cultural vanguard, displaying a dazzling familiarity with the aesthetics of Guillaume, Fry, and A. A. Goldenweiser, the resonance of African idioms and symbols in the poetry of Guillaume Apollinaire and Blaise Cendrars, as well as in the sculpture of Epstein and Lipschitz. Locke's article almost certainly introduced a good many of the magazine's readers to Renoir, Cézanne, Modigliani, and Picasso, as well as to the musicians Honegger, Poulenc, and Satie. Trumpeting the gospel according to Barnes, Locke predicted that "soon primitive Negro art will invade this country as it has invaded Europe." It was inevitable, he said, and with it would come "a new valuation of the contribution of Negroes, past and yet possible, to American life and culture."

Beginning as a somewhat forced phenomenon, a cultural nationalism jump-started in the genteel parlors and offices of the mobilizing elite at the heart of the national civil rights establishment, the so-called Harlem Renaissance was launched in a desperate attempt to improve "race relations" in a time of extreme national backlash against the economic gains won by African Americans during World War I. The recent Great Migration of hundreds of thousands of black people out of the South had transformed racial discrimination from a regional aberration into a national problem—a crisis of democracy. It was the brilliant insight of the men and women largely associated with the NAACP and the Urban League to see that, although the road to the ballot box, the union hall, the decent neighborhood, and the office was blocked by virulent racism, there were two untried paths—arts and letters—that were relatively unbarred in large part because of their very implausibility, as well as irrelevancy to most Americans.

These visionary blacks—the "Talented Tenth," as they called themselves—believed they espied small cracks in the wall of racism that could, over time, be widened through the production of exemplary racial images in collaboration with liberal white philanthropy, the robust culture industry centered in Manhattan, and artists from white bohemia (like themselves marginal and in tension with the status quo). Neither racial militancy nor socialist nostrums could improve the current conditions, warned editor Locke in *The New Negro*, his seminal collection of essays containing a major Barnes piece. "The more immediate hope rests in the revaluation by white and black

alike of the Negro in terms of his artistic endowments and cultural contributions, past and prospective." In setting the goals for their ambitious cultural-cum-civil rights movement, making philanthropic connections, recruiting writers, artists, poets, and musicians, and staging grand interracial banquets where prizes were bestowed, the Talented Tenth African Americans believed they were promoting comity and understanding that would build into a new national consensus about race in America.

Barnes wasted little time applauding their efforts, proclaiming in "Negro Art and America," one of the most influential essays ever to bear his name, that "the renascence of Negro art is one of the events of our age which no seeker for beauty can afford to overlook." For more than a year, his presence in the Renaissance seemed to portend a large, ongoing role comparable to that soon to be played by white music critic and novelist Carl Van Vechten. The following spring saw considerable Barnes activity and spectacular doings at the Foundation. "Negro Art and America" appeared as the first essay in Locke's germinal volume, *The New Negro*, released by Albert & Charles Boni in late February 1926. Barnes elaborated there on the putative special endowments of African peoples, asserting that "the white man in the mass cannot compete with the Negro in spiritual endowment." The collector spoke to the Woman's Faculty Club of Columbia University in March. The subject was "Negro Art, Past and Present," in which he propounded the still novel

thesis that the new era in art derived its inspiration from the "work of the race for centuries despised and condemned to a servile status."

The unlikely relationship between the Lincoln University and the Barnes Foundation was undoubtedly rooted in Barnes's Renaissance experience. It began in appropriately curious circumstances. One of Philadelphia's most distinguished African Americans, the physician and Lincoln alumnus Nathan F. Mossell, was laid to rest on the morning of October 31, 1946. Lincoln's president delivered a funeral oration distinguished both by emotion and content. As Horace Mann Bond left Tindley Avenue A. M. E. Church, he was pounced upon by Barnes who waived the Lincoln president's appointments aside, and hauled him off to Merion. Something about Bond struck a sympathetic chord in the millionaire. After a lunch of milk and crackers, Bond was taken on a tour of the galleries and treated to a lecture on aesthetics. Bond may well have told the inquisitive Barnes something about himself: his doctoral training in sociology at the University of Chicago under Robert Park; his authorship of *The Education of the Negro in the American Social Order* (1934), already a classic; his deep interest in Africa. Barnes may have boasted of the time when he joined with the deceased Mossell and other NAACP leaders in an attempt to prevent *Birth of a Nation* from being shown in Philadelphia.

The two men parted on cordial terms with Bond writing immediately to a Lincoln trustee that the collector was "one

98

of the most remarkable men" he had ever met. If it was "a little premature to ask him for money," President Bond set to work planning how to secure a large donation for the college. He made understanding Barnes a priority, quickly accumulating considerable informed and anecdotal background on the collector's "reputation for irascibility" and fractious dealings with Penn, the Museum, and various colleges. One fact became crystal clear to Bond, that it was a fatal mistake, as one Barnes acquaintance warned, ever "to ask Barnes for anything." What was also clear, Bond ascertained, was that the collector had a long history of "showing interest and affection for Negroes." He quickly discovered the collector's warm ties to the Manual Training and Industrial School for Colored Youth in Bordentown, New Jersey. Bond waited almost a month after their first meeting before writing to the collector. In a letter calculated to draw in Barnes, Bond explained that he had been waiting to receive pictorial materials about a highly successful southern folk music festival in which Fisk University music professor John Work, and poets Langston Hughes and Sterling Brown participated.

Knowing Barnes's suspicious attitude toward academic arts, Bond waxed on a bit about the important role of higher education in preparing a class of persons "able, not only to appreciate, but to preserve the great folk heritage of the Negro people." Could he not get the collector to set a date for a talk to Lincoln's senior class? "How I should like to have been there!" replied the delighted Barnes

about the Fisk festival. Once President Bond picked a convenient Friday for his talk to the seniors, the collector said he would drive over from Merion in his Packard convertible. What a "good omen," one of Barnes's few Main Line friends signaled Bond, adding superfluously, "many people consider him quite difficult to understand." On January 10th, a Friday night, seventeen seniors and foreign students arrived at Horace and Julia Bond's colonnaded mansion punctually at 8 o'clock to hear their legendary house guest, the man, President Bond announced, "who introduced African art to America." The captive audience of Lincoln's best and brightest men had a tonic effect upon the visitor, who was especially intrigued by two of the West African students. The college boasted a proud tradition of educating Africans, numbering among graduates such future national leaders as Nnamdi Azikiwe of Nigeria and Kwame Nkrumah of Ghana. But as Bond explained in considerable detail, conveying his enormous pleasure a week later over receipt of Barnes's check for a thousand dollars, there was no end to the paperwork and expense involved in bringing Africans to Lincoln.

Charmed by attractive, sophisticated Julia enjoying the unaffected worldliness of her husband, and taking wistful notice of their three scrappy children during his overnight stay, the aging collector began to cultivate the Bonds. The Bonds had already laid careful plans to cultivate Barnes. Thanking their host for a Friday dinner and his wife's first tour of the galleries, Bond expertly caressed

Barnes's large, vulnerable ego, telling him that "Mrs. Bond agrees with me that you are at heart and in person a great teacher." Indeed, Barnes reminded him of Robert Park, his own great teacher "also trained in Germany." Bond thought that, of all the splendid paintings at Merion, he most appreciated "the standing figure of the Renoir" in the main salon. By April 1947, the Barnes-Bond friendship had sufficiently advanced that the collector began to confide written accounts of his Penn and Philadelphia Museum disputes to Lincoln's dean of Arts and Sciences, J. Newton Hill.

The president had a few confidences of his own to share with Barnes. He told Barnes of his angry frustration over the racial discrimination against African American teachers and students in the public schools of nearby Oxford Township, and of his refusal to allow faculty children to attend them. Determined to put an end to the policy, he wrote of his decision to run for election to the board of education, which now made him "the most unpopular man in town." Because of his friend's longstanding interest in people of color, he thought Barnes just might like to know how "a solid, patient counsellor of the long view" could suddenly become a "feared and hated 'bad nigger.'" The letter aroused the collector's democratic ire. Bond was doing what few college presidents would do, "coming out flat-footed for democracy as stated in the Federal Constitution and Bill of Rights." He exhorted Bond, who had filed suit against the board of education after losing the election, to take his

story to the *New York Times* and *Philadelphia Inquirer*.

Aside from a small donation, President Bond still had little to show for his cultivation of the collector. "Praise the Lord for the seventeen thousand bucks!" Barnes exulted when the news reached Merion in the fall of 1949 that Nigeria's cocoa farmers had remitted the largest educational subsidy ever to Lincoln; but no check came in Barnes's friendly letter. But Horace Bond had in mind a scheme designed to maneuver his millionaire friend into a meaningfully philanthropic mood. Off to West Africa for five months to recruit students and nurture the generosity of wealthy African donors, Bond astutely asked if Barnes wanted him to "pick up (or try to) any [art] objects for you there?" The collector's excitement about the trip was palpable. Had not his first serious writings in *Opportunity* been about African influences in European art? Africa evoked exhilarating memories of time spent in Paris with Guillaume holding forth on aesthetics. He wished he could go along to the Continent, he wrote excitedly. It had been "one of [his] dreams."

While Bond was away, Barnes was to plunge into darkest humor about the fecklessness of the Philadelphia establishment. Barnes had offered to fund an art course at the Foundation for Penn students, but by November 1949, the collector decided that the University was negotiating in bad faith, wanting only to seduce him into giving away his creation. "This offends my intelligence," he wrote Horace Stern, the friend and

attorney serving as intermediary. The letter closed with what amounted to an anguished cry. He had written it, Barnes said, with sorrow in his heart, "because it is my swan song." A copy of the letter to Attorney Stern was on Bond's desk when he returned from Africa in late January 1950. Knowing that everything to do with Barnes depended on tact and timing, Bond was still undecided whether or not this was the propitious moment to pitch his pioneering scheme for an African studies institute at Lincoln when the invitation to a Labor Day party at the Foundation arrived.

It seems reasonably clear that the Bonds returned from Labor Day at Merion with a proposal for an art institute at Lincoln, faculty to be salaried by the Foundation and classes held there. As a realist, President Bond knew that a groundswell of interest in art classes by the young men of Lincoln was about as likely as a boom in home economics courses. The college ethos was inspired by football and Greek letter fraternities. On the other hand, he was also a visionary who glimpsed a way to achieve his African studies institute in tandem with the Foundation arrangement. Lincoln and the Foundation formally ratified their new affiliation on September 22, 1950. Bond put a bold, flattering face on the future, writing Barnes within a few weeks that the role of the new art course would serve as a "spearhead for reforming the entire institution along intelligent educational lines." He also took heart from Barnes's substantial check. Privately, Bond conceded to a trustee

that the venture was extremely risky and probably doomed to end in "a violent fuss of some kind."

Lincoln's president finally sent the collector his outline for the African Institute, along with an invitation for Barnes to deliver one of the first institute lectures. The word from Merion was encouraging. Agreeing to give a lecture on African art, Barnes informed Bond that the Institute was such a good idea that he had been able to interest Dewey in it over dinner. Dewey had the ear of national foundations. Bond ought to send him a copy of his outline. Heartened by a stream of letters from Merion, Bond developed and refined his Institute concept in order to have evaluations from Barnes and Dewey before submitting a $500,000 proposal to the Ford Foundation. In general terms, the proposal entailed an array of courses in art, anthropology, history, and sociology, with extended research sojourns in Africa ("learning about Africans by living with them," according to Bond) as its centerpiece.

Meanwhile, the arts program was deemed a success, as a dozen or so Lincoln students was transported to the Foundation twice weekly for art appreciation class. The collector lectured on occasion, stressing the concepts of plastic form and objectivity. When Bond drove over to Merion on the first day of March, a Thursday, he found Barnes, firmly resolved to entrust the Lincoln board of trustees with ultimate governance of the Foundation. It was on this occasion that the collector read to the astonished president the terms of the

amended indenture. If Bond continued to pinch himself during the next few days, his incredulity must have been greatly assuaged the following Thursday when Barnes wrote to say that he had "talked it all over with Dewey" who agreed that in the Lincoln-Barnes Foundation alliance "we have the makings of a landmark in education." Having settled the future of his foundation, Barnes shared expansive ideas about funding for the African Institute, now being considered (and soon rejected) by the Ford Foundation. The situation called for a blue-ribbon board of consultants chaired by a distinguished African American. He and Dewey had just the right person for the post—Ralph J. Bunche, United Nations official and the 1950 Nobel Peace Prize Winner, who was uniquely positioned "to do something for Lincoln and interracial relations," Barnes enthused. He, Dewey, and Bond had a winning scheme, but the collector needed to meet with Bunche to explain what had to be done.

Little wonder that Horace Bond spoke of these days as being like "a plot no novel could beat." He dashed off a cautionary letter to his friend Bunche about who Barnes was and what was at stake for Lincoln. A few days later, March 7th, Bond formally proposed Barnes for an honorary degree. The collector attended lectures at the fledgling African Institute in mid-May and went away more enthusiastic than ever. "A certain contentment" gripped him as soon as he passed Lincoln's gates, he purred. With only a few weeks to go until the end of the semester and commence-

ment, President Bond crossed his fingers and temporized. But luck ran against him. Ralph Bunche could not arrange his schedule to meet Barnes and, after two near misses, the collector exploded. He and Dewey were committed to a work of titanic uplift, he raged to Bond. Calling the Bunche evasion "spinach," he sounded ready to write off the experiment—"I say to hell with it." President Bond and Dean Hill assumed it was only a matter of time before they were excommunicated after Barnes was a no-show at the commencement. Undaunted, Bond dispatched a car to deliver the honorary degree diploma and hood.

The silence from Merion was deafening. Finally, an invitation came. On July 17, a Tuesday, the Bonds, Hills, and several faculty members were entertained at the Foundation by Albert and Laura Barnes. Plans for the next year's art course and the Institute were discussed. Bond felt that it had been "a very good visit," and he was delighted to see the Lincoln diploma framed and hanging on the wall in Barnes's office. The following Tuesday afternoon, July 24th, 1951, Albert Barnes's convertible Packard was flattened by a milk truck as it barreled through a stop sign on the Phoenixville road near the owner's country retreat. Barnes died instantly, alone except for his little dog. In the weeks that followed the probation of the collector's will, Lincoln anxiously waited for some sign from the Foundation that the amended indenture shown to Bond in early March was still valid. Pondering his extraordinary relationship with Albert Coombs Barnes,

Horace Mann Bond put his thoughts on paper as the fall semester of 1951 wound down. "I have the feeling that I can only sit and wait and hope and let the drama unfold," he reflected. "If it turns out to be the miracle I would like it to be, I will feel great satisfaction."

MIDWESTERN MEDIEVALISM: THREE CHICAGO COLLECTORS

Neil Harris
The University of Chicago

Most of the treasures now held by American art museums were gathered by private individuals for varied reasons and with divergent aims. This art typically resides in comfortable anonymity within the neutral and decontextualized spaces museums generally offer. Labels normally note its immediate provenance. But rarely in any narrative depth. The motives and strategies which structured a collection's assembly, as well as the routes objects traversed before arriving at their final resting places, merit attention for many reasons: aesthetic, economic, social, and intellectual. At a minimum they propose patterns to institutional development, suggesting just how collectors worked with (or against) dealers, experts, curators, and administrators. Focusing upon one midwestern museum, The Art Institute of Chicago, and one arena of collecting—medieval and Renaissance art—I hope to reconstruct this history by juxtaposing three significant collectors (fig. 1). Their lives illuminate the complex links between collector identity and museum function.

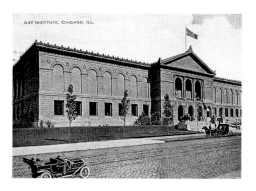

Fig. 1. The Art Institute, ca. 1909 (from a postcard). All photographs in this essay are from the Ryerson Archives of the Art Institute of Chicago and are © 1996, The Art Institute of Chicago. All Rights Reserved.

It is in the interest of recovering the amalgam of boosterism, altruism, egotism, and civic leadership which constitute the history of patronage, that I create this narrative.

Entering today's Art Institute, once past the entry lobby a visitor stands at a crossroads. Front and center is a grand staircase which leads up to the famous painting collections. Just beyond, to the left, are passageways to prints and drawings and to Amerindian and African arts; to the right, the recently installed Asian galleries. And looming up ahead, beyond

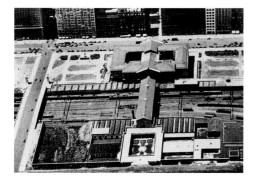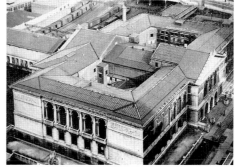

Fig. 2. The Art Institute, overhead view, 1925–30, when the three collectors were all active.

Fig. 3. The Art Institute, overhead view, 1934.

a set of glass doors and a modest group of steps, is a long narrow hall which has spanned the Illinois Central tracks since its construction in 1916. It is lined with exhibition cases; at its center stand glass vitrines and several armored figures. This is Gunsaulus Hall, home to the Art Institute's early European decorative arts. The cases on the right are filled with small objects, many of them originally of household or religious use: Majolica drug pots, Spanish earthenware, crucifixes. On the left hover hundreds of weapons: halberds, pikes, daggers, poleaxes, pistols, rifles, many of them intricately decorated. And in the center, along with the armor and elaborately embroidered copes, is an extraordinary Florentine glazed terra cotta altarpiece, six feet high, the Adoration of the Shepherds. The label declares this a gift of Kate S. Buckingham for the Lucy Maud Buckingham Memorial Collection. There are other Buckingham gifts in the cases on the right, small gothic or Jacobean objects, although far fewer than the glassware, enameled reliquaries, and earthenware that declare *their* origins to have been the Martin A. Ryerson Collection. The weapons on

the left, and the armor, again as label copy tells us, are from the George F. Harding Collection. Nothing in this hall indicates who Ryerson and Buckingham were, although a printed placard identifies George F. Harding.

In actual fact, among them, Buckingham, Ryerson, and Harding represent the multiple aims which nurtured this institution, the errors and false starts as well as the achievements. Other notable donors aided the medieval collections — Potter Palmer, Charles Deering, Julius and Augusta Rosenwald, Chauncey McCormick, names tied deeply to the city's most celebrated establishments — but these three remain special. Their collecting ambitions illuminate both their life histories and the shifting sources of local leadership (figs. 2–3).

Of the three, Martin A. Ryerson (fig. 4) stands first.[1] Largely unsung outside Chicago, he was the Art Institute's single greatest benefactor, his gifts extending far beyond medieval and Renaissance art. Among other things Ryerson collected ancient coins, South American and Asian textiles, Near Eastern glass, Japanese books, Chinese porcelain, classical pottery, and French impressionist

and post-impressionist art; he was de-
voted to Monet, visiting him at Giverny,
and donating a series of his canvasses,
along with works by Pissarro, Renoir, and
Cézanne, to the Art Institute. Present
day Chicagoans, when they recognize
Ryerson's name at all, associate it with
the city's passion for French impression-
ism. But during his lifetime Ryerson was
better known for his pioneering pursuit
of French, Flemish, and Italian painters
of the fourteenth and fifteenth centuries,
primitives they were called then, an inter-
est that began in the 1890s and extended
to a variety of art objects of the late mid-
dle ages and early Renaissance.[2]

Ryerson typified a defining moment
in the city's history, a generation of civic
philanthropists coming of age in the
1880s and 1890s who presided over a
golden age of giving and institution mak-
ing. Born in Michigan in the mid-1850s,
the son of a timber magnate, he grew up
in Chicago, studied in Paris and Geneva,
and on returning home entered Harvard
Law School; he graduated in 1878. After
marriage and a brief legal career he en-
tered the family lumber business, taking
over the firm in 1887 upon his father's
death. By the early 1890s, however,
having added to the considerable family
fortune he inherited, barely into his
forties, Ryerson retired from business to
dedicate himself to local philanthropies.
His three favorites were the Columbian,
later the Field Museum, the University
of Chicago, and the Art Institute. He
served each as an officer; he was presi-
dent of the University Board for thirty
years, and vice-Chairman of the Art

Institute for twenty-three. Childless, he
and his wife occupied the very center of
Chicago's social and financial elite.

Quiet, self-effacing, cultivated, and
scholarly in appearance as well as taste,
Ryerson left few clues to his personal
feelings. We have only some speeches,
several letters, and a highly specific and
unopinionated set of journal entries.

Fig. 4. Martin A. Ryerson.

No autobiography or candid remarks
amplify these documents. His values
were evidenced by his actions. Despite,
or because of, Ryerson's failure to leave
a revealing written record, he has fasci-
nated at least half a dozen scholars who,
in one way or another, have tried to
account for both his collecting and his
philanthropies. One art historian has
suggested the influence of Charles Eliot
Norton, teaching at Harvard and spread-
ing his enthusiasm for the Italian Renais-
sance during the years that Ryerson was
at the Law School.[3] Norton, moreover,
actually visited the Columbian Exposi-

tion of 1893 where he might have encountered Ryerson. No actual evidence supports this connection, however. Others have pointed to his wide reading and the influence of figures like John Ruskin and Matthew Arnold.[4] Ryerson was a book collector himself, but even more significantly, endowed the Art Institute's own library and helped turn it into a major center (fig. 5). There were other possible sources of inspiration in people Ryerson knew and admired. Family history might have played a part; his parents, for example, who decided to send him to boarding school in Paris in the 1860s, an unusual course for a Chicago family. His wife's role may well have been significant. But again, barring the appearance of more direct evidence, one must work from the art itself and the pattern of his life's work.

Ryerson was, in some ways, the ideal philanthropist: well educated, cultivated, and with time and money to pour into his favorite causes. As a believer in institutions, he willingly submerged desire for personal celebrity beneath a commitment to their long-term welfare. He met needs as they appeared. Thus his funds for the library came in response to an appeal for support. At the University of Chicago he contributed the physics building that housed the work of America's first Nobel Laureate in science, Albert A. Michelson. Ryerson admired scholarship for itself, but his generosity was channeled to meet specific demands.

In similar circumstances he helped the Art Institute acquire its first group of high-quality paintings. During its first

ten years, until 1889, according to Ellis Waterhouse, the museum bought only one old master, and that by a rather obscure artist. Thus in 1890 when the Ryersons and their inseparable friends, the Charles Hutchinsons, found themselves in Paris attending an art sale, they determined to do something by purchasing a dozen paintings en masse from the collection of Prince Demidoff. The Demidoffs had been selling pictures for decades, but even after earlier sales the

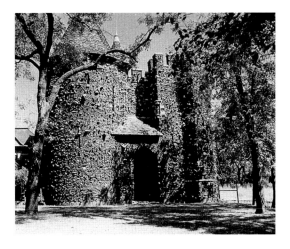

Fig. 5. The library of the Ryerson home, 1880s.

works available in 1890, by Franz Hals, Rubens, Rembrandt, and Van Dyck, were exceptional.[5] Ryerson and his associates presented several to the Art Institute almost at once, and got other Chicago collectors to pay off and donate other Demidoff items. Again, in 1906, Ryerson helped organize a group to purchase El Greco's *Assumption of the Virgin*, for a time the Art Institute's signature painting. It took years for this debt to be paid back.

From one perspective, then, Ryerson was an accommodationist, stepping in where others, from egotism or lack of confidence, might have hesitated. His position was invariably supportive rather than critical. But Ryerson also had tastes of his own, and indeed held off giving the museum funds for its own buying. After his death in 1932 the Art Institute received one third of a six million dollar estate, but during his lifetime, Ryerson's cash gifts totaled only $250,000, and much of this went into the library. He preferred to choose himself what would hang on the museum walls, instead of relying upon curators and committees. Certainly, Ryerson's taste for primitive paintings served an institutional need because the Art Institute had little representing the Renaissance or Middle Ages. No Isabella Gardner or Henry Walters or John G. Johnson or J. P. Morgan lived in Chicago. Interest in early religious art was light. But Ryerson did not need the support of a circle of fellow collectors; although he patronized major dealers dangling impressive authentications, he made his own decisions.

Ryerson started collecting while a teenager, during his student days in Paris. But serious interest developed only in the 1890s, after his father's death. His first major early purchases came through Durand-Ruel from the 1892 sale of the Earl of Dudley's collection. These included four Perugino predella panels that remain today among the prized possessions of the museum, and, similarly, a Pontormo portrait of Alessandro de' Medici. Durand-Ruel did not normally handle early Italian art, but Ryerson placed a series of specific bids with him and the dealer complied with his wishes. The amounts Ryerson specified were conservative; indeed, he lost some important things at this sale because he was unwilling to go very high.[6]

But he knew what he wanted. Heavily involved with trustee responsibilities at several institutions, he did not buy quantities of early art during the 1890s. He acquired other work from the Ehrich

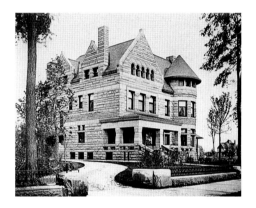

Fig. 6. Martin A. Ryerson's home on Drexel Boulevard.

Gallery, but it was not until 1910 or so that Ryerson, with twenty years of institutional experience, dealer contact, and extensive viewing, resumed his early collecting in force, sustaining it for the next fifteen or so years with dealers like Kleinberger, Knoedler, Scott & Fowles, Horace Morison in Boston, Langton Douglas in England, acquiring dozens of significant works by French, Italian, and Flemish masters, all of course, besides his modern paintings.[7] With impeccable provenance, many came from the

Fig. 7. The Ryerson home interior, between 1924 and 1927.

most celebrated collections in Europe, acquired at fabled sales, both before and after World War I: the Marczell de Nemes collection, originally in Budapest, sold in Paris in 1912; the Rodolphe Kahn collection, handled by Duveen; the Dowdeswell collection in England; the Edward Weber collection in Hamburg; the de Somzée collection in Brussels; the the Emile Gavet, Jean Dollfus, Rothan and Arago sales, and so on. This was operating on the highest, most sophisticated level of art gathering. The painters acquired included Rogier van der Weyden, Gerard David, Ridolfo Ghirlandaio, Spinello Aretino, Taddeo di Bartolo, Giovanni di Paolo, along with many decorative art objects. Martha Wolff, curator at the Art Institute, argues that Ryerson's taste, which became more ambitious and consistent in the post-War period, concentrated upon paintings that

were, in her words, "complex, finely wrought, and personal—often intimate —in their communication."[8] He preferred the relatively austere Umbrian and Tuscan painters to the more sensuous Venetian school.[9] Spending large sums on his collecting, Ryerson, immediately after purchasing them, put many of the pictures on display in the galleries of the Art Institute.

But he also kept many favorites at his home on South Drexel Boulevard, not far from the University of Chicago (fig. 6). His house, still standing, was large and elegant, but not an extraordinary showplace. The pictures and objects were carefully arranged and privately enjoyed, but they were lent out frequently to the Art Institute, to a point where things he still owned were listed in the Art Institute catalogue. During the teens and twenties, as the earlier paintings became

better known to specialists, Ryerson's home was visited by a stream of noted art historians and critics, profuse in their tributes to his taste as well as his hospitality (fig. 7). They included Frank Jewett Mather of Princeton, Lionello Venturi of Turin, Richard Offner, Paul Sachs, Raimond van Marle, Bernard Berenson, and William Valentiner.[10]

Ryerson's highly personal and focused tastes, well informed by contemporary scholarship, were backed by a fortune that permitted him to pay high prices for acknowledged masters and gain the aid of recognized experts. The specialist and future director of the Detroit Institute of Arts, William Valentiner, was looking for things that Ryerson might like in Europe; he created the collector's catalogue, never published and not quite scholarly enough for Ryerson's taste.[11] The Ryerson art, moreover, was spread through the Art Institute, subject to no restrictions. When he died, Ryerson left everything to the museum, except for things remaining in the house, and those came six years later on the death of his widow. The total included almost eighty nineteenth- and twentieth-century European paintings, thirty-seven Italian primitives, twenty-five French and Flemish primitives, Japanese textiles and objects, forty American paintings, thirty-seven eighteenth-century Dutch, French, Spanish, and Flemish oils, many watercolors and prints, and a host of applied objects of many kinds, including the medieval pieces on display in Gunsaulus Hall.[12] While galleries in the Art Institute bear Ryerson's name, they are there

to acknowledge his generosity; his gifts are scattered with no attempt to emphasize their origin. A few attributions have changed in the course of time, but almost nothing in the Ryerson collections has been found to be mediocre, forged, or false. His judgments have stood up well, for relatively little has been deaccessioned.[13] As benefactor and collector he stands in a classic civic line, linking his reputation to the institution and the city, following no obvious fashion in taste, and apparently unconcerned about posthumous fame. He knew what he was getting and made few mistakes.

Holding a similar social rank in Chicago, and, as near as one can determine, just as wealthy as Ryerson, was another Art Institute benefactor. While her presence in the museum today is subdued, this adjective could not be applied to her in life. Kate Sturgis Buckingham was driven by different goals (fig. 8). The granddaughter of an Ohio pioneer, she was born two years after Ryerson, in Zanesville, Ohio, in 1858.[14] And it was her family and the places they lived—Zanesville and Chicago—that aroused Kate Buckingham's deepest loyalties. Brought up on Chicago's street of millionaires, Prairie Avenue, she enjoyed the wealth created by her banker father, Ebeneezer Buckingham, a powerful figure in the city in the years just before and after the Great Fire of 1871, much involved in grain elevators, street railways, and banking. Kate Buckingham moved through a life of privilege—wintering in Arizona, summering in western Massachusetts, in

Fig. 8. Kate Buckingham.

both cases on family estates. Little is known, beyond occasional anecdotes concerning her penchant for good works, about her early years. She, and her two siblings, Clarence and Lucy Maud, never married, and in some ways her life would be dominated by their needs and interests.

In fact, it was her older brother, Clarence, who became the family's first collector. Like other Chicagoans Buckingham found his life changed by the World's Columbian Exposition in the summer of 1893. Captivated by the Japanese display on the fair's Wooded Island, within a short time he emerged as an enthusiastic collector of Japanese wood block prints. In this he was complemented by a local architect named Frank Lloyd Wright, soon simultaneously collector and dealer. In 1908, Wright, Buckingham, and a bank employee and collector named Frederick Gookin organized a showing of more than six hundred Japanese prints at the Art Institute, where Clarence Buckingham served as a trustee.[15] The installation proved a triumph for Wright and the show a landmark in emerging American taste for Japanese art. But five years later, in 1913, Clarence Buckingham died suddenly, one year after his father. The fourteen hundred prints in his collection were moved to the Art Institute and Frederick Gookin became their first curator.

Kate Buckingham now had her brother's memory to promote, and indeed, much of her next twenty-five years was devoted to keeping the family's name visible within the city. She provided funds to increase the collection—today more than ten times the size of the group Buckingham left—and deeded all the prints, and an endowment, to the Art Institute in 1925. Two years later, she perpetuated her brother's name with an even more extravagant gesture, a $750,000 fountain in Grant Park which remains one of the city's most popular and recognizable landmarks seventy years later.

By then Kate Buckingham had gotten into her own collecting, although it was again in the family interest. Her sister, Lucy Maud Buckingham, was invalided. According to legend, Kate Buckingham commenced collecting to amuse her sister in the years after her brother's death. Starting about 1915 she began to acquire Chinese porcelains, snuff bottles, and other "curios." Presumably her brother's interest in Asian art had served as something of a spur, along with an existing collection of Chinese objects given the Art Institute by another Chicagoan, Samuel Nickerson. With her brother's fortune added to her own, there then came her sister's inheritance, after Lucy

Maud Buckingham's death in 1920. Kate Buckingham was now one of the wealthiest women in Chicago. During the 1920s she moved from the Prairie Avenue home her father had built into a cooperative apartment on the North Side, incorporating within it some rooms of the older house, which she then razed. Family piety was a strong point with Kate Buckingham. And it was to memorialize her sister that she became involved with the arts of the Middle Ages.

But here she demonstrated the short-comings of enthusiasm insufficiently checked by expertise. Kate Buckingham's Oriental collections were guided by some of the country's most knowledge-able curators as well as her own taste. She bought from important collections in an area that the Art Institute was already well established; the museum housed an extensive set of experts, actually more than for Western arts, supplemented by other specialists like Berthold Laufer of the Field Museum.[16] There were important local dealers. Her personal delight in the Chinese bronzes that she presented the museum was palpable, even if she might have been nudged toward these purchases by museum curators.[17]

But in determining to create a gothic memorial to her sister she stumbled badly, spending large sums of money on objects that only a couple of decades later embarrassed the object of her generosity. Why Kate Buckingham decided upon a gothic setting as an appropriate memorial to her sister is unclear. She

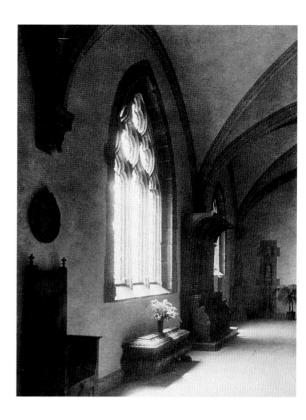

Fig. 9. Lucy Maud Buckingham's Gothic Room (1924).

may have been moved by the architectural and sculptural casts, particularly those from gothic Europe, that dominated the Art Institute in its early years, or she may have wanted to fill in collection gaps. But in seeking evocation as a goal she was moving down a road which dozens of American art museums were taking during the 1920s. Period rooms were a craze of the decade—in Brooklyn, Philadelphia, New York, and Boston as well as in Chicago—some of them actual reconstructions of specific settings, more often composites designed to project an almost cinematic feel for the period and a comfortable setting for the art.[18] "To enter the Gothic Room is to step into another world," gushed the Art Institute's *Bulletin*.[19]

The Lucy Maud Buckingham Memorial Gothic Room, as it was called, was the largest of the series of period rooms that would be established in the Art Institute, although not the first (fig. 9). Three years earlier had come the Jacobean Room, given by Kate Buckingham in memory of her parents.[20] But this portrait-lined room from Wales was overshadowed, in scale and expense, by the Gothic Room that opened in 1924, attempting to bring together sculpture, tapestries, architectural details, and the minor arts in the interest of establishing a unity of expression. Kate Buckingham purchased for it furniture and household objects designed to evoke an era set somewhere between A.D. 800 and 1500, a culture, the Art Institute Curator of Decorative Arts, Meyric Rogers, wrote a bit later in his guide to the collection, "as foreign to us as the cultures of the pre-classical world and the Orient."[21] In the interest of suggesting this exotic past, and emphasizing continuities between the religious and secular worlds, Kate Buckingham spent more than $300,000 on the stained glass, candelabra, mantles, gothic doors and furniture, sculpture, paintings, and other things that filled the room. She bought from dealers like Jacques Seligmann, Louis Cornillon, Kleinberger, P. W. French, Mitchell Samuels, Kelekian, Joseph Brummer, De Motte, Anderson Galleries, and others of well established reputation. In this room, and the Jacobean Room as well, she wanted her own name invisible. These were family memorials and, despite a penchant for mischievous publicity particularly concerning her entertaining and travel habits, Kate Buckingham did not require public adulation for her gifts. At one point she had thought of setting up her own gallery, but decided instead to place everything within the Art Institute itself. For her departed relatives, however, recognition was central.

But something went wrong with her European collecting and Miss Buckingham apparently realized it. When the museum's registrar, G. E. Kaltenbach, wrote her in 1933 that a Swiss tapestry specialist had dated one of her gifts to the Gothic Room as being woven no later than 1400 (and a superb example of its kind) she answered almost immediately. It was "a novelty to find anything I have given to the Art Institute that is not 'questionable,'" she observed acerbically. And then she complained about the task of finding suitable objects for an institution that remained skeptical of her best efforts. "I have tried so hard to never offer them anything that has not been passed upon by the best 'experts' I could secure," she explained. "After paying all their expenses" to and from New York, "in order to get the VERY BEST," and after apparently accepting their judgments, locals remained unconvinced. Frustrated and perhaps a little amused, Miss Buckingham thanked Kaltenbach for his kindness in complimenting her, and resignedly turned back to her purchasing.[22]

In fact, her worst fears would be realized. Two years after her death in 1938, Daniel Catton Rich, the museum director, issued a confidential and depressing

report to the Board of Trustees.[23] Relying upon a detailed analysis of the decorative arts collections by Professor Ulrich Middledorf of The University of Chicago, the curator, and a British expert, Rich concluded that the Jacobean and Gothic halls stood in need of immediate action. The Gothic Room, installed at a cost of almost $100,000 had consumed, along with its objects, some $500,000. The results were, to say the least, disappointing. The 1940 Report on the Buckingham Collections was marked "Confidential" with a note attached, "Do not communicate to anyone except on express request from the Director (that means everybody)." The evaluation of individual objects was dominated by comments like "Strongly suspect—largely made up," "Poor style—probably made up," "Mostly, if not all, modern," "Forgery," "Questionable," "Doubtful." Some objects earned the high commendation of "Possibly genuine—poor" or "Genuine but mediocre." The objects included chairs, niches, portals, cassoni, paintings, statuary, and the amounts paid ran from $75 to $31,000 for a Spanish Madonna described as "Probably genuine—third quality," and $110,000 for the Mille Fleurs tapestry, which did, after all, prove to be genuine. Experts declared that it would be useless to reconstitute the Memorial. "The room is a poor forgery and should be replaced by a genuine example...." The recommendation was to set aside $16,000 to completely reestablish the room, with the assistance of a recognized expert. Presenting the report to his director, the curator declared that the Memorial was "far from any acceptable museum standard and is by no means worthy of the generous intent of the donor." He urged an immediate removal of forgeries. But acknowledging the rarity of genuine medieval material, he had no sense of what to do about the larger group of objects.

There is no Gothic Room in today's Art Institute, nor any Jacobean Room either. The Buckingham Fund continues to allow the Art Institute to purchase individual objects of importance; several Asian collections and the Buckingham prints exist as they do largely because of Kate Buckingham's benevolence. And, in Gunsaulus Hall, significant individual pieces continue to mark her earlier intentions. But as settings the Buckingham Memorial rooms are gone. Kate Buckingham had broad interests; she supported dozens of aspiring musical artists; aside from the fountain she left one million dollars to memorialize Alexander Hamilton in a public statue, to her mind the greatest American political leader of the Revolutionary years. And her benefactions to the Art Institute, in objects and cash, totaled millions of dollars. But as a collector of medieval objects she demonstrated the pitfalls confronting wealthy amateurs when they bought with greater enthusiasm than discernment, or when a powerful and knowledgeable curator was unable to provide greater direction.

Her collections also demonstrated how uneven taste could be within a single collector. For the Asian materials, culled though they may be, are among

the Art Institute's most significant objects. It was in trying to assemble the gothic and Jacobean objects that the collector faltered. In the end, Kate Buckingham was a booster—of the city, of her family, of the Art Institute, of her political views. Irreverent, unpredictable, witty, and hostile to sham and pretension—in her old age she once held a dinner party to honor a new wig—she was also deeply committed to her role as a collector-patron. "When I was a girl," she was quoted in later years, "Chicagoans had to travel far and wide to see things of beauty. I am glad I have lived to see the day when people come from far and wide to see things of beauty in Chicago."[24] Drawn to collecting in her fifties, first as a device to amuse an ill sister and then to memorialize her brother and her parents, to piety and boosterism she added, undoubtedly, special affection for many of the things she bought. But unlike Ryerson her connoisseurship was limited and she became prey to overly enthusiastic, ill informed, or loosely principled dealers.

The Buckingham story is both impressive and cautionary. While her financial endowments and Asian art interests have been crucial to the growth of the museum's collections, the monies expended on the memorial rooms, were, if not thrown away, damaging to both institutional ambitions and the goals of memorialization. Could curators have steered Kate Buckingham away from more obvious frauds? Would she have permitted them to do this? Were curators less influential in shaping collecting goals and methods in the early twentieth

century than dealers? Surviving materials do not explain why, amid the skepticism of local experts, Kate Buckingham continued to present the museum with dubious or unimpressive pieces. But this may well have been a more characteristic patron pattern than the masterly reputations of figures like Ryerson, Isabella Stewart Gardner, John G. Johnson, and others of that era.

As a medievalist, Kate Buckingham's role in the Art Institute was paralleled unexpectedly by a third collector, George Franklin Harding, who, were he alive now, would be bitterly disappointed by his institutional fate and marginal status (fig. 10). A figure of prominence sixty years ago, he has practically vanished from popular consciousness, except for occasional press articles that recall his surprising career.

Harding was born in Chicago in 1868, twelve years after Ryerson and ten after Buckingham.[25] Sent to Phillips Exeter Academy, Harding graduated from Harvard College and, following his father, Harvard Law School. Like his brothers he was a star athlete—boxer, oarsman, and football player. This may have prepared him for entry into Chicago politics, a more plausible scenario for a Republican ninety years ago than it is today. At a particularly colorful point in the city's history, in 1903, he was elected alderman of the second ward, and after several terms went on to the Illinois Senate. A successful realtor—he was known as the Millionaire Alderman—he became a major adviser to the city's Republican mayor, the fabled "Big Bill" Thompson.[26] In 1919

Fig. 10. George F. Harding.

Harding was elected comptroller of the City of Chicago, and in 1926 Treasurer of Cook County. This was his last public office. Prominent enough to be invited to lunch at the White House with President Hoover, in 1936 he became Republican National Committeeman for Illinois, a major participant in the disastrous campaign of Alf Landon. Three years later, in 1939, he died. Had this been all there was to Harding's career it would have been interesting if unremarkable.

However, for the last twenty years of his life Harding was also an active, impassioned, and ambitious collector. He amassed an extraordinary array of items, among them canes, posters, musical instruments, paintings, sculpture, ship models, figureheads, rugs, and weather vanes. But he was best known as one of the four or five most prominent American accumulators of medieval and Renaissance armor and associated weapons. Despite his catholicity of taste, one magazine writer noted in 1932, "it is certain that the middle ages have taken a

strong hold on his imagination, as shown by the great hall where his armor-clad knights hold sway...."[27] His principal rivals in armor gathering were millionaires like William Randolph Hearst and Clarence Mackay, or specialists like Bashford Dean, curator of the Metropolitan Museum's collection, Stephen V. Grancsay, his successor, and C. Otto von Kienbusch, who would give his armor to the Philadelphia Museum of Art. Harding competed on the world market for this armor, was advised by Dean and Kienbusch, and remained in constant touch with them. He visited Europe at least once each year, contacted dealers throughout the world, and engaged in complex and often expensive gambits to move precious armor out from under governmental authorities in Spain and Austria.

How and why did this collecting begin? Interviewed in his later years, Harding declared that the collection— really just things he and his father liked —got started during his father's lifetime. While settling his father's estate, he explained to reporters, he got drawn in himself.[28] His collecting activity was confined largely to the 1920s and 1930s, when he also moved to a large house on the south side of the city, not far from The University of Chicago, and there, alongside the tracks of the Illinois Central, he created a large addition, part French château, part fortress, that became for several decades one of the sights of the city (fig. 11). Here, amid spectacular if crowded interiors, Harding showed off his remarkable assembly of objects, includ-

ing sixty-four suits of armor, two-hundred-and-fifty nineteenth-century paintings, an important group of Frederick Remingtons, Chopin's piano, instruments used by Beethoven and Liszt to compose upon, and other significant association pieces including a bed slept in by Napoleon, a huge rug once owned by the Grand Duke Alexis of Russia, a suit of armor presented by Queen Victoria to the ten-year-old Crown Prince Friedrich Wilhelm of Germany, and a chaise lounge on which Abraham Lincoln had once stretched (figs. 12–14). He formed the Harding Museum as a non-profit corporation in 1930; admission was free, and the museum was open, in non-summer months, five days a week. There are no figures on attendance, but local residents, high school and university students, boy scouts, clubs and societies, and visiting notables made frequent visits. "Here is the artist too, then, who collects for sheer love of art, and is not afraid to mingle a patronage of the more

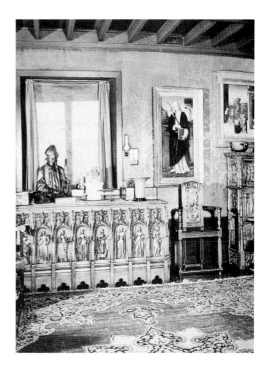

Fig. 11. Harding's Castle.

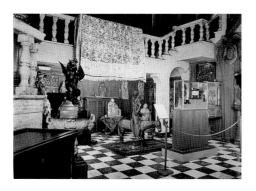

Fig. 12. The Main Room at the Harding Museum.

recent painters with the acquisition of the antiques," spouted one visitor.[29]

The Harding Museum, in short, was a modern *wunderkammer*, a cabinet of curiosities on which Harding claimed to have spent millions of dollars in the two decades he collected. As a professional politician, Harding valued publicity and proved to be an inveterate self-promoter. He accumulated forty volumes of press clippings, reports cropped whenever his name, or the name of any family member, appeared in print, no matter how minor the reference. From time to time Harding declared his intention to give the collection to the people of Chicago. Occasionally he indicated the Art Institute might be his recipient.[30] The problem here was Harding's insistence

that everything be kept together.[31] Although objects from the Harding collection were indeed shown at the Art Institute from time to time, and Director Robert Harshe apparently enjoyed good relations with Harding, offering advice on certain purchases, clearly much of the display was considered inappropriate, in terms of subject, medium, quality, and/or authenticity. But Harding, apparently, insisted on all or nothing, and the public gestures to the Art Institute came to naught.

Why Harding bought, beyond his armor and weapons collection, is unclear. He sought out fine armor with the aid of recognized experts, and paid high prices. But the other things were matters of whim and opportunity. Whatever was curious, inexpensive, and appealing, and would add to the atmosphere of his castle, served his taste. The range of dealers Harding dealt with was much broader than those serving either Ryerson or Buckingham; they included several who made extravagant and insupportable claims, and whose clients—and business methods— could be equally shady. Harding was hospitable as well as flamboyant, opening his house for special groups, encouraging students to attend, and maintaining, simultaneously, a busy political schedule. At his death, in 1939, the non-profit corporation he had established took over, and for several decades the Harding Museum remained open.

But its location proved its undoing. When, in the 1950s, the neighborhood underwent radical urban renewal, the Harding complex was doomed. Before

Fig. 13. The interior of the Harding Museum with armor.

Fig. 14. The Harding Museum, musical instruments.

Fig. 15. The Harding Collection in the Crerar Library building.

the buildings were razed all the furnishings and some of the exhibition objects were auctioned off. The trustees decided to rent space on several floors of the old John Crerar Library. On the corner of Randolph and Michigan, one block from Marshall Field's, the downtown site held promise, but that promise went unfulfilled.

The display was now quite different. The blank white walls could not supply the theatrical, even menacing atmosphere of Harding's castle (fig. 15). And this building itself would soon come down, to be replaced by an office skyscraper. The trustees of the Harding Museum confined themselves to warehousing the objects, sending out selections to Midwestern venues, and paying themselves large salaries.

Indeed, it is here that the story assumes its most dramatic character. Ever since Harding's death his estate had been involved in litigation, and when it was discovered that portions of the collection were being sold to meet expenses, investigations began.[32] Ultimately, state legislation was produced, defining more clearly the fiduciary responsibilities held by trustees of non-profitable institutions. As part of a complex settlement, the Art Institute was given its choice of the remaining Harding materials, by then in a New York warehouse. From them it selected large portions of the armor and weapons, and dozens of other pieces — Remington paintings, medieval sculpture and occasional panels, and some smaller objects. The vast majority of things were sold, and the monies distributed to relevant departments to be used for acquisitions.[33]

Even with so drastic a reduction, the Art Institute's armor probably constitutes one of the three or four best assemblies in the country. Here Harding's knowledge and advice proved equal to the task, but the array of objects which made his castle so memorable have now been scattered and his name has practically vanished from the local scene.

The three stories I have summarized contain both obvious parallels and arresting contrasts. All three patrons lived about the same time, were born to wealth in prominent families, were well traveled and, in two cases at least, well educated, possessed varied interests, and were civic loyalists. Their medievalism, while only one collecting enthusiasm of many, typified their approaches to art more generally. Ryerson's private, intensely personal response to art's emotive contents was a source of communion with semi-religious values, particularly at home. Kate Buckingham's medievalism was a memorializing instrument, evoking her sister and asserting the family line through a shrine-like domestic setting. For Harding it was combat — buccaneering, heroic, confrontational, and bombastic — that underlay his medieval enthusiasms. Private devotion, family commemoration, and warfare: not an improbable triad to abstract from the Middle Ages.

Today, however, each collector is represented not by themes or interests but by individual pieces earning their places at the table only after professionals have applied their standards of connoisseur-

ship and authenticity. Institutional shapers have become institutionally shaped. In this sense Kate Buckingham's most lasting contributions were her cash endowments, permitting the Art Institute, particularly in the 1940s, to buy medieval objects of greater quality than any she purchased. Ryerson, on the other hand, though he left more money to the Art Institute than Kate Buckingham did, was so able a selector that very little art of the quality he himself gathered could be garnered with the income he provided. Harding was in many ways the most singular of these figures, the most determined to protect his dream of what a museum should look like and his highly personal approach to collecting. But the course of events has eclipsed him more fully than either of the others: his dramatic and sentimental vision of art, warfare, and human history now subdued by the Art Institute's very different approach to classification and display. Harding's vision may yet obtain more attentive nurture by the Art Institute, but for the moment his grand ambitions are bounded by shares in a single exhibition hall.

Are there lessons from all this? Moralists might note that the most modest of the three collectors, Martin A. Ryerson, has achieved the greatest posthumous reputation: nice guys finish first. Professionals might conclude that when donors seek curatorial help—Mrs. Buckingham and her Asian collections—they gain most success: experts have something to contribute. Cynics might argue that the Art Institute still has no medieval galleries as such nor a full-time curator of

armor: cash counts most. But these conclusions are quick fixes to more complex issues.

Strong institutions absorb and even efface strong individuals. Today's Art Institute—in layout, scope, and display logic—departs strikingly from the place patrons knew seventy years ago. It is simultaneously more inclusive and more selective, less evocative but more focused. Its heart, however, remains the gifts it has received rather than the art it has purchased. For all its professional independence it has relied on the kindness of friends and, in Harding's case, of rivals. The comprehensive museum of art hosts a dialogue between the shaping ambitions of curators and directors and the motives and taste of its donors. At present, in most of these institutions, a professionalized ideal appears to have triumphed; museum arrangements and exhibition programs reflect this vision. Provenance, institutional history, collector intention, all are downplayed in philosophies of display, in favor of strict criteria for authenticity, segregation by media or period, and occasional controlled systems of evocation.

But this may not be a permanent destination. As audiences shift and ways of dramatizing the museum broaden, personalized visions may swell to dominance in the future, or at least museums may decide to exploit their histories more aggressively. Many gallery spaces have already changed their functions and character more than once. And some notable collectors outside Chicago —Robert Lehman, Benjamin Altman,

Walter Annenberg, and John G. Johnson among them—have had their demands for permanent identity met, at least for the moment. The history of our greatest museums is dynamic, more dynamic perhaps than Ryerson, Buckingham, and Harding might have guessed, and more dynamic also than contemporary planners might suspect. In these surprises, as historians as well as citizens, we may take some pleasure as well as alarm.

1. Ryerson's significance as a benefactor was treated in the *Bulletin of the Art Institute of Chicago* 27 (January 1933), in what amounted to a memorial issue, with several brief essays devoted to him by various curators, and extracts from a memorial address by Director Robert Harshe. The extent of Ryerson's influence was shown by the fact that separate articles evaluated his gifts of paintings, oriental objects, classical objects, prints, decorative arts, and books. No biography of Ryerson has been written but he has been treated by a number of scholars. A brief summary of his life is provided in Dumas Malone, ed., *Dictionary of American Biography* (New York: Scribner's, 1943), vol. 16, pp. 272–273. A chapter is devoted to his career in Aline B. Saarinen, *The Proud Possessors* (New York: Random House, 1958). Helen Lefkowitz Horowitz, *Culture & The City. Cultural Philanthropy in Chicago from the 1880s to 1917* (Lexington: University Press of Kentucky, 1976) examines Ryerson's activities within the context of Chicago philanthropy. A stimulating interpretation of Ryerson's collecting is offered by Stefan Germer, "Traditions and Trends: Taste Patterns in Chicago Collecting," Sue Ann Prince, ed., *The Old Guard and the Avant-Garde. Modernism in Chicago, 1910–1940* (Chicago and London: University of Chicago Press, 1990), pp. 171–191.

And, more recently still, Martha Wolff has analyzed Ryerson's taste in Christopher Lloyd et al., *Italian Paintings before 1600 in The Art Institute of Chicago. A Catalogue of the Collection* (Chicago: Art Institute of Chicago, 1993), "Introduction," pp. xi–xvi.

2. Evidence for this can be found in the Ryerson Papers, Art Institute of Chicago, notably letters of inquiry and congratulation sent to Ryerson which largely concerned these earlier works.

3. See Helen Horowitz, *Culture & The City*, p. 73. The Norton influence is suggested also in Ellis Waterhouse, "Earlier Paintings in the Earlier Years of the Art Institute: The Role of the Private Collectors," *Museum Studies* 10 (1983), pp. 79–91.

4. For the influence of Ruskin and Arnold more generally on Chicago civic philanthropists see Horowitz, *Culture & The City*, chapter 4, pp. 70–92.

5. The purchase of these pictures from the Demidoff collection has been described in many places. For more on the Demidoff family and their earlier collecting see Francis Haskell, "Anatole Demidoff and the Wallace Collection," *Anatole Demidoff. Prince of San Donato (1812–1870)* (London: Wallace Collection, 1994), pp. 9–31.

6. Martha Wolff, "Introduction," pp. xi–xii, describes the Durand-Ruel purchases.

7. Bills and letters reflecting these purchases and Ryerson's contacts with specific dealers can be found in the Ryerson Papers.

8. Wolff, "Introduction," p. xiv. And see the appreciation of Ryerson's pioneering taste and an ambitious effort to characterize it in Daniel Catton Rich's essay, "The Paintings of Martin A. Ryerson," *Bulletin of the Art Institute of Chicago* 27 (January 1933), pp. 3–14.

9. Rich commented that Ryerson probably enjoyed his Florentine paintings even more than the Sienese; "he was never misled by the extreme mannerism of her [Siena] painters; nothing was further from his preference than some of her swooning Madonnas." Rich, "The Paintings of Martin A. Ryerson," p. 12.

10. Frank Jewett Mather, Jr., the art critic and Princeton art historian, thanked Ryerson for his hospitality in a letter of January 24, 1920, Ryerson Papers, declaring that for French primitives only the John G. Johnson collection in Philadelphia was equal to the Ryerson assembly. Paul Sachs, impressed on seeing Ryerson's things at the Art Institute in 1915, "pictures of superlative quality," he wrote at the time, thanked Ryerson ten years later for inviting him to his home for more picture viewing (Paul J. Sachs to Ryerson, March 22, 1915, and January 13, 1925, Ryerson Papers). In his first letter, Sachs wrote, "I trust you will not take it amiss if as a stranger I write all this and congratulate you on your remarkable achievement. May I also express my admiration for the liberal spirit which prompts you to make available to the public so great a collection." Even strangers expressed their gratitude. In 1922 an anonymous out of towner who visited Chicago each summer partly to see Ryerson's art, commended him for his breadth and taste, and thanked him for the joy of seeing the paintings. "What I write," the correspondent concluded, "is only a part of what I feel about those loans of yours; I am only one of hundreds who, like myself for years past, keep silence." (Anonymous to Ryerson, August 1, 1922, Ryerson Papers).

11. Ryerson was also concerned about the cost estimates Valentiner was getting. See W. R. Valentiner to Ryerson, January 11, 1930, Ryerson Papers. Ryerson, under instructions from G. E. Kaltenbach, the Art Institute Registrar, used a special cable code for Valentiner, who was finding things for the Art Institute in the early 1920s. Patrons like Ryerson and Kate Buckingham were buying literally for themselves but actually for the museum. This complicated the tasks of the staff in innumerable ways.

12. Ryerson's gifts were reviewed in the *Bulletin of the Art Institute of Chicago* 27 (January 1933) issue commemorating his achievements; another issue of the *Bulletin* 32 (January 1938), appearing after the death of Mrs. Ryerson, further reviewed the gifts, and described the exhibition that began in January, 1938, showing the range of Ryerson's generosity.

13. Ryerson's conscientiousness about attribution was noted by Daniel Catton Rich in his 1933 essay. "Too often a group of pictures come into the permanent trust of a museum, overlaid with wrong attributions, puffed up with false reputations. But Mr. Ryerson cared little for such things; he was always ready to change a greater name for a smaller, if the smaller seemed more just." Rich, "The Paintings of Martin A. Ryerson," p. 6.

14. Biographical information on Kate Buckingham is taken from obituaries, including the one in the *Chicago Tribune*, December 15, 1937, and a reminiscence, February 4, 1938, occasional recollections, and a couple of brief sketches including one with occasional inaccuracies in Patricia Erens, *Masterpieces. Famous Chicagoans and Their Paintings* (Chicago: Chicago Review Press, 1979), pp. 77–99.

15. For the history of Asian collections at the Art Institute see Elinor L. Pearlstein and James T. Ulak, *Asian Art in the Art Institute of Chicago* (Chicago: Art Institute of Chicago, 1993). Margaret Gentles, "Clarence Buckingham: Collector of Japanese Prints," *Apollo* 84 (September 1966), pp. 208–215, offers a brief summary of Buckingham's enthusiasm. His sisters apparently attended the "print parties" Buckingham hosted in his home for other friends of Japanese art.

16. Thus in 1926 the staff of the Art Institute contained four people concerned with Oriental art: Charles Fabens Kelley, the Curator of Oriental Art; Doris K. Wilson, the Assistant Curator; Helen Gunsaulus, Keeper of Japanese Prints; and Frederick W. Gookin, Curator of the Buckingham Prints. In addition Berthold Laufer, Curator of Asiatic Ethnology at the Field Museum of Natural History and an advisor to Kate Buckingham, had been serving, since 1920, as Honorary Curator of Chinese Antiquities. At the time the Institute's total curatorial staff numbered only seven.

17. The Buckingham Chinese bronzes grew in number, said Curator Kelley in an obituary notice, because Kate Buckingham "had an instinctive reaction to a bronze of superlative quality and found it difficult to resist adding it to her collection." Charles Fabens Kelley, "The Buckingham Chinese Collection," *Bulletin of the Art Institute of Chicago* 33 (April/May 1939), p. 52. Some of the Chinese art she bought was later reassigned to an earlier date. But "attributions did not interest her particularly, and she would never have dreamed of advancing an opinion of any sort about the technical questions involved." The collection was known officially as the Lucy Maud Buckingham Collection, in memory of her sister. For more on Kate Buckingham's Chinese art interests see Elinor Pearlstein, "The Chinese Collections at The Art Institute of Chicago: Foundations of Scholarly Taste," *Orientations* 24 (June 1993), pp. 36–47

18. For more on the period room craze see Dianne H. Pilgrim, "Inherited from the Past: The American Period Room," *American Art Journal* 10 (May 1978), pp. 4–23; and Osmund Overby, "The Saint Louis Art Museum: An Architectural History," *Saint Louis Art Museum Bulletin* 18 (fall 1987), pp. 18–22.

19. *Bulletin of the Art Institute of Chicago* 18 (May 1924), p. 54.

20. See *Bulletin of the Art Institute of Chicago* 15 (January 1921), p. 122 for a description. A picture of the Jacobean room can be found in the *Bulletin* 15 (March 1931), p. 131.

21. Meyric R. Rogers and Oswald Goetz, *Handbook to the Lucy Maud Buckingham Medieval Collection* (Chicago: Art Institute of Chicago, 1945), p. 74.

22. Kate Buckingham to G. E. Kaltenbach, November 1, 1933, Kate Buckingham Correspondence, Art Institute of Chicago. Kaltenbach's letter was dated October 30, 1933. The Swiss specialist was C. B. Gans.

23. The comments and quotations are taken from a report of the director to the president and members of the Buckingham Committee, dated May 15, 1940, and from the study that precipitated it. It can be found in Box 2, file 4 of the Buckingham Papers at the Art Institute. The basis of Rich's report was an examination undertaken by curator Meyric Rogers and Ulrich Middledorf, along with an outside specialist from Stuart and Turner Ltd. The curator argued that while further expertise should be sought, the verdicts offered "will in the main be confirmed."

24. These lines are quoted, without attribution, in Erens, *Masterpieces*, pp. 91–92. They are also quoted, along with her pride in her midwestern origins, by Chauncey McCormick and Walter B. Smith in the "Buckingham Memorial Notice," *Bulletin of the Art Institute of Chicago* 33 (April/May 1939), pp. 50–51.

25. Details of Harding's life are taken from Paul T. Gilbert and Charles Lee Bryson, *Chicago and Its Makers* (Chicago: Felix Mendelsohn, 1929), p. 963; Albert Nelson Marquis, ed., *Who's Who In Chicago and Vicinity* (Chicago: A. N. Marquis, 1936); the obituary in the *Chicago Tribune*, April 3, 1939, p. 18; and from the voluminous Harding Scrapbooks, dozens of volumes now in the archives of the Art Institute of Chicago. An analysis of Harding's collecting is provided by Walter J. Karcheski, Jr., *Arms and Armor in The Art Institute of Chicago* (Boston, New York, Toronto, London: Art Institute of Chicago and Little, Brown, 1995), which appeared after this essay was completed. He came from a remarkable family. His grandfather had moved to Monmouth, Illinois, in the 1830s, served in the legislature, became an anti-slavery leader and Civil War general, and acquired a fortune through real estate and railroad development. His son, George F. Harding, attended Knox College in Illinois, and in 1851 took his law degree from Harvard, the first Illinois graduate of the University. He practiced for a time in Peoria with another aspiring Illinois attorney, Abraham Lincoln, and would attend Lincoln during his 1858 debates with Stephen A. Douglas. Young Harding, with his father, helped create what would become the Chicago, Burlington & Quincy Railroad, and, with both acquired and inherited wealth, became active in politics and public interest law. Among other things he helped pass legislation limiting railroad fares, and led the bitter fight against Chicago's street car trust. Immensely successful in real estate he had seven children, including three sons who attended Harvard. One of them was George Franklin Harding.

26. Harding was valued for his ability to "deliver" thousands of African American votes to the Thompson machine, voters in his own and in neighboring wards. See, for example, Lloyd Wendt and Herman Kogan, *Big Bill of Chicago* (Indianapolis and New York: Bobbs-Merrill, 1953), *passim.*

27. Ruth G. Bergman, "Treasure–An Exploration of the Castle on the I. C.," *Chicagoan* (April 1932), p. 25.

28. See, for example, Charles Newton, "G. F. Harding's Collection of Art Enviable," *Chicago Herald and Examiner*, November 26, 1933. This article, which is in the Harding Scrapbooks, vol. 24, also contains an extensive description of the collection.

29. Beth Goode, "The Hon. George F. Harding," *The Woman Athletic* (January 1931), p. 10.

30. Among those who thought this would be the destination of Harding's armor was his fellow collector, Stephen V. Grancsay, who wrote him from the Metropolitan Museum of Art, June 2, 1931, "I can appreciate what a wonderful thing it will be to have your collection installed there [The Art Institute of Chicago] permanently." Harding Papers, Art Institute of Chicago. Harding had left two dozen objects from his collection to the Metropolitan for a summer exhibition. Harding and Grancsay corresponded regularly about possible purchases from various collections.

31. The clipping books contain a series of newspaper and magazine reports describing Harding's offers. *Art World* during 1932 or 1933 reported that unless the Art Institute accepted the entire collection, other plans would be formulated.

32. A summary of the Harding case is provided by Jane Allen and Michael Vermeulen, *New Art Examiner* (March 1977).

33. *Bulletin of the Art Institute of Chicago* 76 (July/August 1982), p. 11, announced that ownership of the arms and art work from the Harding Museum had been transferred to the Art Institute, and promised a special exhibition to be mounted within a year. This followed upon negotiations between the Harding Museum directors and various local institutions. *The Chicago Tribune* ran articles and columns on the transfer of the collection to the Art Institute in May and June, 1982. The investigation by the Illinois Attorney General had begun in 1976; an Internal Revenue Service probe had also been undertaken.